SELF-TAUGHT AND OUTSIDER ART

ANTHONY PETULLO

INTRODUCTION BY JANE KALLIR

ARTIST BIOGRAPHIES,

EXHIBITION HISTORIES,

AND SELECTED BIBLIOGRAPHY

BY MARGARET ANDERA

THE ANTHONY PETULLO COLLECTION

UNIVERSITY OF ILLINOIS PRESS

URBANA AND CHICAGO

self-taught
& outsider art

∞ This book is printed on acid-free paper.

Photograph on p. vi courtesy of Luke Irons Photography, New York, N.Y.
Photographs on p. 2 courtesy of Larry Sanders Photography, Milwaukee, Wis.

Library of Congress Cataloging-in-Publication Data
Petullo, Anthony.
Self-taught and outsider art : the Anthony Petullo collection / Anthony Petullo ;
introduction by Jane Kallir.
p. cm.
Includes bibliographical references and index.
ISBN 0-252-02666-7 (cloth : alk. paper)
1. Outsider art—Europe—Catalogs. 2. Outsider art—United States—Catalogs.
3. Petullo, Anthony—Art collections—Catalogs. 4. Art—Private collections—
United States—Catalogs. I. Title.
7432.5.78 47 2001
709'.04—dc21 00-012569

CONTENTS

Acall from Alex Gerrard, an art dealer in Robertsbridge, England (formerly in Battle), in January 1990 started the whirlwind journey that changed my life. Alex had seen Bill Traylor's *Brown Mule* pictured in the *New York Times* as a promotion for a forthcoming Sotheby's auction. His telephone message was short: "Buy it!" Traylor, a self-taught artist who had been born a slave in Alabama in 1854, had created this marvelous work, a simple animal drawing, in 1939 at the age of eighty-five. As soon as I saw it, I knew that I would buy it; and it is still one of my favorites pieces. Later that same month Alex found *Schooners* by Alfred Wallis, a retired marine stores dealer born in Devonport, England, in 1855; it too had been painted in 1939, and I added it to my collection as well.

Since that first Sotheby's purchase, Alex Gerrard and many other dealers and advisers have assisted me in building a unique collection of remarkable work by self-taught artists. From 1993 to 1995, ninety-five pieces from my growing collection went on a six-museum tour that started at the Museum of American Folk Art in New York City. Countless groups and individuals have also visited my home and business to view my collection. Talking about the artists and their work, and the passion I have for collecting it, is one of my greatest pleasures.

As I write this, my collection totals more than four hundred pieces, about two-thirds by Europeans and the rest by Americans. Many of the European artists are virtually unknown in this

country. I was fortunate to begin collecting when so many great works were still available. Since the explosion of interest in self-taught and outsider art in the mid-1990s, the best-quality pieces have become increasingly difficult to find.

I greatly admire the creativity, inventiveness, and unspoiled style of the true self-taught artist. With few exceptions, the artists whose works are in my collection have been true to themselves and have had little outside influence. Most of them have had a consistent, recognizable style throughout their careers. Unlike many trained artists who search for meaning and a unique style, the great self-taught artists just let their brush or pen go to work. They make no attempt to impress the viewer, to imitate another artist, or to improve their style. They are good and they know it.

Countless stories circulate of trained, sometimes famous artists being influenced by and even trying to emulate a particular self-taught artist. It is interesting to note that the majority of great self-taught artists were discovered, admired, and even promoted by trained artists. Ben Nicholson and Christopher Wood stumbled upon Alfred Wallis in St. Ives, England. Charles Shannon befriended Bill Traylor, a Montgomery, Alabama, sidewalk artist. Jim Nutt was introduced to the work of Martin Ramirez by a psychiatrist, Dr. Tarmo Pasto. Jean Dubuffet was overwhelmed by the creativity of a number of the patients in European mental hospitals and began painting in a style that resembled their work, referring to it as *art brut*. These trained artists all saw unique artistic qualities in the works of their self-taught, self-inspired friends.

"Outsider art," a term coined by Roger Cardinal of the University of Kent, and *art brut* refer to works by artists who are outside the mainstream of life, the mainstream of the art world, or both. A few trained artists are included under these rubrics, a liberty Dubuffet took in classifying artworks and one that I take as well. For example, Patrick Hayman (p. 72) is a trained artist whose work has all the features of self-taught or outsider art. Not included in either category are folk artists, especially American spiritualists or three-dimensional artists. The majority of out-

sider art is by Europeans, and few of them work in three dimensions. Many have suffered mental illness or extreme introversion. Most are rigidly devoted to a uniquely inventive art form.

Much like the outsider artists who march to their own drummers, with little regard for those watching the parade, I collect what appeals to me personally. Although I have solicited and been offered advice by dealers, critics, curators, other collectors, and friends, the final decision to purchase an artwork is always mine. My collection has a style of its own, a unique fingerprint. It has an integrity and continuity that could not be achieved by a committee.

A senior Sotheby's North America executive once defined collecting as the "process of acquiring and possessing, but perhaps more importantly, it is the process of selecting. It is the collector's choices, the works that appeal to him most directly and the connections between them that give the collection its unique force and character." It has been said that there are two types of collectors: those who focus on the individual objects and those who concentrate on the interrelationships among the objects, on their synthesis. According to Julie Hall, a folk-art collector, synthesis is what distinguishes a collection from an accumulation.

In my opinion selectivity and patience are the most important elements in building a collection. While it is relatively easy to find works by many of the artists included in this book, it is quite difficult to find their *best* works. That requires careful consideration of a body of work rather than just a few readily available pieces. That means visiting art dealers, auction houses, collectors, and the artists themselves; sometimes it also means relying on resource materials that include photographs of the artist's work. What must be resisted is the temptation to purchase a piece of art simply because works by that artist are hard to find.

As you look through this book and make your own assessment of the artworks in my collection, you should bear in mind what goes on before a piece of art appears in a museum or a home or an office or a book. As a trustee of the Milwaukee Art Museum I have learned a great deal about caring for and presenting a collection. Researching artists and their work, art conserva-

tion, framing and properly hanging each piece, controlling light, heat, and humidity, photographing artworks, developing a library, dealing with artists and their agents, and insuring works of art have all become important parts of my life.

Why do I go to all this trouble? Because I want my collection to be the best of its kind. Because I want to be proud of it when I show it to others, when I allow people to see something unique, something they wouldn't be able to see anywhere else.

One of the most gratifying aspects of owning this collection is hearing people say how much they enjoy seeing it and hearing about the art and the artists. I hope that will be your experience as you read about this most unusual and talented group of artists and view a representative sampling of their best work.

I HAVE BEEN THINKING about publishing this book for a few years. My collection is such a great source of joy for me that I wanted to be able to share it with as many people as possible. With the help of friends, dealers, and family, what was once just a thought has now become a reality.

There was much we had to do to prepare for this. Every piece included in the book was removed from my home or business and taken to a studio for photographing. We had to search for a publisher, contact guest writers, and hunt down photographs of the artists themselves. I am grateful for everyone's dedication and enthusiasm.

Special thanks go to Cynthia Peterson, who handled much of the administrative and data collection activities. She has been involved with my collection almost since the beginning, and her work was instrumental in getting this project off the ground. Thanks also to my daughter, Amy Cesarz, and to Beth Hoye, both of whom assisted with final manuscript changes.

Heartfelt thanks go to those people who gave so much of their time and talents to make this a book of which to be proud. Margaret Andera, assistant curator at the Milwaukee Art Museum, authored the artist biographies and compiled the exhibition histories and the selected bibliography, in addition to being an excellent project consultant. Jane Kallir, owner of the Galerie St. Etienne in New York City, wrote a very comprehensive, informative introduction and served as an invaluable resource. Long-time friend and British art dealer Alex Gerrard has been my trusted adviser over the years. He helped me discover the works of many wonderful European artists, and through him I was able to purchase art never seen before in the United States.

When we began our hunt for photographs of the artists, Alex located Jill Livsey, who provided a unique portrait of her old friend James Dixon and also wrote down her memories of him. Alex arranged for others to contribute personal stories about the artists they were close to, and he wrote his own recollections about Sylvia Levine. We are grateful to all of them for sharing their memories. We also owe a debt of gratitude to all of the dealers, galleries, museums, insti-

tutions, and families who provided photographs from their archives, files, and family albums. To be able to view the faces of these artists adds to our appreciation of their work.

In this regard I must share the story of locating photos of the Polish artist Nikifor. We saw one photo in a book, but it was unattainable. For weeks Cynthia searched on the Internet, sending out e-mail to any Nikifor reference she could find. Finally she happened upon the Muzeum Nikifora in Krynica, Poland. She telephoned the museum only to find that no one there spoke English. So close to the goal, she asked around for anyone who spoke Polish and learned that my son-in-law, Joe Cesarz, had studied Polish at the University of Pennsylvania. Joe phoned Elizabeth Sachs, a lecturer at the university, who agreed to contact the museum in Poland and translate our needs. The museum curator graciously shared with us the photograph that appears on page 134.

Finally, I wish to thank the designer, Kristina Kachele, and the outstanding group of professionals at the University of Illinois Press who assisted in producing this book, especially Willis Regier, director; Judith McCulloh, assistant director and executive editor; Theresa L. Sears, managing editor; and Copenhaver Cumpston, art director. I am proud to be a graduate of the University of Illinois and proud to call the University of Illinois Press my publisher.

SELF-TAUGHT AND OUTSIDER ART

The Collector in Context

JANE KALLIR

Throughout the ages, collectors have served as the primary link between artists and the broader public. Their patronage ensures artists' material survival, while their custodianship preserves the artworks themselves. Along with collectors' cherished gatherings of carefully chosen objects, their aesthetic values are bequeathed to subsequent generations, who in turn subject the objects to their own processes of collecting and reevaluation. Yet despite these crucial functions, collectors figure tangentially, if at all, in most histories of art. This is in part because collectors' tastes are by nature idiosyncratic, whereas art historians attempt to formulate global judgments based on a perceived consensus. Then, too, collectors are amateurs in the first and best sense of the term, and art historians are understandably inclined to protect their professional turf. The juxtapositions of objects that collectors create are often no more arbitrary than those proposed by curators, but as a rule collections are as mortal as their progenitors. Works get dispersed or jumbled together with other items in museums, and the original collector's vision, always underappreciated, is eventually effaced entirely.

At the dawn of the twenty-first century, we are actively reassessing the traditional narratives that have been used to chart our history. In the case of art, rigid hierarchies of value and linear notions of "progress" are being jettisoned in favor of a looser, more egalitarian approach. Recognizing that the formalist aesthetic that dominated the art world as recently as twenty years

ago was conditioned by a white, male, Eurocentric bias, we are now open to a broader variety of ethnic and artistic options. In the process, people have become more aware of the multiple societal forces that shape taste. Our revised art-historical narrative documents the interaction of these forces, rather than lionizing individual artist-heroes or positing qualitative absolutes.

These changes in our approach to art history have sweeping implications both for our understanding of the collector's role in a general sense and, specifically, for the appreciation of "outsider" or "self-taught" art.[1] By focusing less exclusively on artists and more generously on the myriad other shapers of taste, we allow the collector a more visible place on the stage of art history. At the same time, our eagerness to embrace a host of unconventional artistic traditions has given new legitimacy to self-taught art. And, most curious of all, there seems to be a subliminal connection between these two phenomena, for the recent surge of interest in self-taught art is almost entirely a collector-generated initiative. This is one trend in which the academics have lagged far behind.

The Anthony Petullo Collection thus can be read on several levels. First and foremost, the story of the collection is the story of one man's odyssey: his adventures, his triumphs and mistakes, his vision and ambition. But Petullo is also emblematic of a certain type of collector and of a specific collecting phenomenon, and his odyssey therefore must be examined within the context of the field of self-taught art as a whole. As a collector, Petullo to a degree helped create that field, though he would hardly claim normative status for his own selection criteria. Nevertheless, given that as yet there is no agreement on an acceptable definition for outsider or self-taught art, Petullo's selection criteria—honed over two decades and yet largely intuitive—offer at least one plausible, cohesive way of organizing an inherently unruly body of material.

BEFORE turning to the specifics of the Petullo Collection, we should review the larger history of self-taught art. Although self-taught art per se has always existed, the *field* of self-taught art is essentially a modernist construct. At the beginning of the twentieth century, as the European

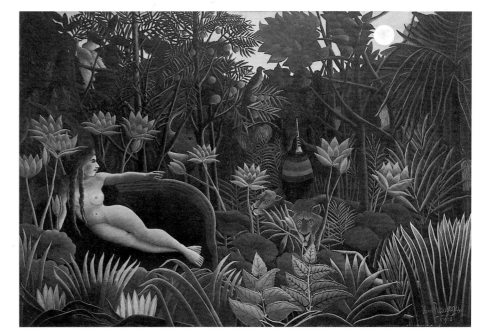

Henri Rousseau, *The Dream*, 1910, oil on canvas, 80½ x 117½ in. (204.5 x 298.5 cm). The Museum of Modern Art, New York. Gift of Nelson A. Rockefeller. Photograph © 2000 by the Museum of Modern Art, New York.

avant-garde attempted to break free of the academic tradition that had heretofore separated "high" art from everything else, people began for the first time to look seriously at the work of a number of artists who, for various reasons, had been denied formal training. Interest in self-taught art was one segment of a much larger anti-academic trend that also encompassed non-Western exemplars (such as Japanese prints and tribal art), indigenous folk crafts, and the work of children. The first contemporary self-taught painter to capture the attention of the avant-garde was the French toll collector Henri Rousseau who was discovered by Picasso and his circle in the early years of the twentieth century and featured in the German Expressionist manifesto *Der blaue Reiter Almanac*, in 1912.[2]

After World War I, as the European avant-garde began to develop a broader popular following, champions of the new art naturally developed a concomitant interest in self-taught creators. Initially, Rousseau had seemed an isolated case, but it was not long before other painters of similar inclinations were unearthed. Commonly dubbed "naives" (based on a pejorative misreading of Rousseau's personality), these self-taught painters popped up in almost every country affected by modern art, but they were particularly numerous in France, where the art dealer and writer Wilhelm Uhde established a sort of movement under the rubric "Painters of the Sacred Heart."[3]

Artists and curators familiar with European modernism brought an awareness of self-taught art to the United States in the 1920s and 1930s. Here, too, initial interest in the genre was quite

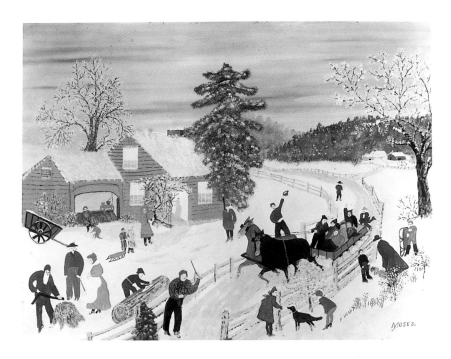

Grandma Moses, *Joy Ride*, 1953, oil on masonite, 18 x 24 in. (45.7 x 61.0 cm). © 1953, renewed 1981 by Grandma Moses Properties Co., New York, N.Y.

far-ranging and included a fascination with earlier American folk artifacts. The search for a contemporary "American Rousseau" soon yielded results when in 1927 a Pittsburgh house painter named John Kane (p. 78) was admitted to the prestigious Carnegie International Exhibition. No less an institution than the fledgling Museum of Modern Art pledged its support to self-taught art, and the genre rapidly became a relative commonplace in the nation's more forward-thinking galleries and museums. As in Europe, there was no short supply of artists to fill the new demand.[4]

Over the course of the 1940s, the American art establishment gradually withdrew from the field of self-taught art, choosing instead to throw its full weight behind the emerging Abstract Expressionist movement. Rightly or wrongly, the arbiters of taste came to perceive a rift between naive art, which was eminently accessible to a broad range of people, and the nascent American avant-garde, whose work was difficult and hence judged artistically superior. The mass appeal of Grandma Moses—surely the most popular self-taught artist of the century and also one of the most successful artists of her time[5]—only served to confirm this prejudice. Moses was, in fact, so successful that she spawned a host of imitators who persist to this day. This proliferation of *faux naïfs* has indeed cast a lasting pall on the entire naive branch of self-taught art.

In Europe, the genre of naive art developed along lines that were roughly parallel to those prevalent in the United States. By the 1960s and 1970s naive paintings were routinely turning up

on calendars and dinnerware, and the style had emerged as a staple of children's book illustration. Once this genre became a received style instead of a self-invented one, it was essentially dead. Rampant commercialization called into question the very viability of naive art. How, one might rightly ask, could anyone in this age of mass-market periodicals, television, and radio remain truly remote from culture? Even if an artist had not gone to art school and hence was self-taught in the most literal sense of that term, how could any visually sentient person avoid being saturated by a plethora of pictorial matter? How could he or she fail to have heard of Grandma Moses? The strict division that Picasso and his generation had perceived between the academically educated and the self-taught no longer seemed to hold.

The first generation of naïfs—from Rousseau through Grandma Moses—consisted of people who might well have become professional artists had fate dealt them different hands. It was for the most part economic circumstance that prevented these people from pursuing artistic careers and forced them instead into more practical pursuits. The vast majority began painting late in life, after retirement, and their artistic goals remained relatively conventional. The first-generation naïfs were essentially picture-makers out to record their external surroundings, and their work tends to fall into the orthodox categories of landscape, portraiture, and still life. Nevertheless, this early contingent of self-taught artists was sufficiently remote from mainstream culture to develop startlingly original technical and pictorial solutions.

In the second half of the twentieth century, it became evident that economic circumstances alone could no longer generate the cultural isolation required to produce a genuine naïf. And this, in turn, led to a focus on the more extreme aspects of lifestyle embodied in the currently popular (if controversial) designation "outsider." Outsider art is the English counterpart of the French *art brut* (literally, "raw art"), a term first used in 1945 by the artist Jean Dubuffet as a catchall for work created by artists who operate at the farthest remove from received culture. Dubuffet began by collecting art made by mental patients, and *art brut* is still largely associated

(some would say wrongly) with the work of the mentally ill.[6] In Dubuffet's scheme, mental illness was only one of a number of possible factors that might position an artist on the margins of culture and thereby set up the circumstances requisite to the production of *art brut*.

Dubuffet had invented a concept that was both compelling and fundamentally unworkable. He would spend the rest of his life honing definitions without ever arriving at an entirely satisfactory solution. As Dubuffet's collection of *art brut* grew—eventually to the point where it commanded an entire museum[7]—he was forced to recognize that an art totally divorced from culture was an ideal rather than a reality. He determined that it would be more practical to define *art brut* by placing it on a continuum somewhere between the acultural and the fully cultured (the "raw" and the "cooked," as it were). Yet the question of how and where to draw the boundaries along this continuum remained unanswered. Eventually, Dubuffet coined the term *neuve invention* (new invention) to cover those artists whose work, though somewhat *brut,* was not quite pure enough to qualify as *art brut.* In Dubuffet's museum, these artists would be housed in a separate annex.

From the start, it seemed clear that, whatever it was, *art brut* was inherently different from naive art. The naive artists, with their conventional notions of picture-making, were far too clued in to received culture to qualify as *brut.* Where the naive artists looked outward, to their surroundings, the *brut* artists tended to look inward, recording visions and obsessions that were on some level meaningful only to themselves. Their distance from received culture was not only aesthetic but personal, which posed a logistical dilemma for connoisseurs of *art brut:* at a certain point, aesthetic judgments would have to defer to judgments involving creative authenticity. An artist might create something that looked *brut,* but if the artist was too savvy about cultural issues, then the work would have to be disqualified as *art brut.* Yet ignorance of wider cultural issues generally demanded an extreme degree of marginalization in the artist's lifestyle. Much as Dubuffet might protest that there is no such thing as an art of the mentally ill (any more, he would say, than there is such as thing as an art of people with bad knees), *art brut* came to be defined at least partly in terms of the artist's biography.

The problem of definition and the uneasy reliance on artists' biographies only grew worse when *art brut* was translated into English and eventually traveled to the United States as outsider art. The term "outsider art" was, as it happens, a rather arbitrary coinage, selected by the British art historian Roger Cardinal as the title for his 1972 survey of *art brut* from a list of possible names proposed by his editor at Praeger. The British definition of outsider art did not, at first, differ markedly from Dubuffet's admittedly nebulous definition of *art brut*. However, as outsider art began to gain currency in the United States, the definition started to blur. The sharp divide that Dubuffet had seen between the naive and the *brut*, difficult enough to sustain in Europe, proved even more untenable in America.

The United States did not establish art schools until the late nineteenth century, and so the distinction between academic and nonacademic art was less meaningful here than it had been among the European avant-garde in the early years of the twentieth century. Due to America's distance from the European academies, our young nation had a much richer tradition of historical folk and self-taught art than was common in the Old World. It was therefore never clear whether our modern self-taught artists were simply extending the practices of their nineteenth-century predecessors or belonged in an entirely different category. Nor, for the most part, did American connoisseurs respond as strongly to the art of mental patients as did their European counterparts. Americans instead tended to lump all self-taught art together as expressions of the stereotypical rugged individualism that is so much a part of our national myth. The kind of theoretical hairsplitting so dear to the Europeans—between naive and *brut*, between true *brut* and *neuve invention*—never had much appeal in the United States.

Without this theoretical rigor, the term "outsider" became increasingly meaningless; applied sloppily, it also had the potential to be profoundly offensive. On the one hand, there were those who used the word "outsider" as though it were a synonym for "self-taught," casually throwing together artists such as John Kane (p. 78), who in Europe would be classified as a naive, with the likes of Martin Ramirez (p. 150), a mental patient who falls more logically into the *art brut* camp.

On the other hand, as the outsider label began to gain advocates among collectors and dealers, there were those who focused on biography almost to the exclusion of all else. Autism, schizophrenia, mental retardation, and the like became, in the crudest hands, marketing tools. When the designation "outsider" was applied to African-American artists—who because of their intrinsically marginal status were prime targets for the new trend—the label acquired covertly racist connotations. "Outside of *what?*" members of the African-American community might rightly have asked. To be sure, these artists were operating outside mainstream white culture, but they were still very much within their own legitimate communities.

Collectors do not typically concern themselves with theoretical squabbles, but every collector of self-taught art must in some fashion negotiate a veritable minefield of conflicting ideologies and disparate types of art. Needless to say, each collector's approach to this situation is different, and there are probably as many different collections of self-taught art as there are definitions of the field. Anthony Petullo's collection, as it happens, hews fairly closely to the categories (naive, *art brut* and *neuve invention*) outlined here. In Petullo's words, the artists he favors are either "true naives," "true outsiders," or "marginal outsiders." Yet he did not set out to follow a preformed agenda, and the visual shape of his collection is very much of his own making. Moreover, when he first began collecting, the field of self-taught art as we know it today did not exist.

ANTHONY PETULLO'S interest in self-taught art dates to the mid-1970s, when he discovered the work of a local artist, Pat Thomas, at a juried exhibition in his hometown of Milwaukee, Wisconsin. Petullo was almost a complete stranger to museums, and he had never before looked seriously at art, never studied it, and certainly never purchased it. Nonetheless, he became deeply involved with Pat Thomas, who might best be described as a second-generation naive painter. Petullo endeavored to help Thomas negotiate a safe path through the sometimes unscrupulous art world and eventually even established a gallery primarily to sell her work.[8] Petullo soon branched out to collect the work of other artists of Thomas's ilk. Many of them turned out to be

faux naïfs, and their work did not wear terribly well over time. As Petullo grew to be a more experienced collector, he hungered for work that was more substantial, more satisfying. It would, however, take a decade or more before his collection found its present direction.

The mid-1970s was in some respects a particularly inauspicious time to begin a collection of outsider art in the United States. In part because of the prevalence of *faux naïfs*, the field of twentieth-century self-taught art had been entirely written off by academe. It is significant that the Whitney Museum's 1974 survey of the genre, *The Flowering of American Folk Art*, contained no twentieth-century material whatsoever. As the curator, Alice Winchester, put it, "American folk art came into flower during the early years of our nationhood, and by the last quarter of the 1800s it had begun to fade."[9] Using criteria that revolved around preindustrial norms, scholars like Winchester had simply defined modern self-taught art out of existence. Even a specialized institution such as New York's Museum of American Folk Art had a board dominated by collectors of eighteenth- and nineteenth-century material.[10]

The Americans who chose to collect self-taught art in the 1970s, and in essence paved the way for Petullo,[11] did so without any prospect of mainstream support or validation. This situation was very different from that which had greeted the first American collectors of self-taught art in the 1930s. Often followers of the European avant-garde, these early collectors were encouraged by informed artists and curators to acquire folk and naive art.[12] Similarly, *art brut* in Europe was principally the domain of a cadre of respected artists and allied intellectuals. American collectors of contemporary outsider art, by contrast, had no elite guides, no road map to follow. They literally had to make up the field as they went along.

These circumstances are at least partially responsible for the disparate materials and conflicting agendas that today constitute the field of self-taught art in America. Since it was up to each collector to formulate his or her own definition of the field, the final definition naturally varied from person to person. Academics came in after the fact (as they are indeed doing today) and validated different collectors' visions by writing about the material or exhibiting it or acquiring it for a

museum. But this is one case where the subtle rearranging that art historians practice in working with objects does actual damage to the history of those objects, because in a very real sense the history of outsider art is the history of collecting outsider art.

That history has yet to be written, and even a modest attempt would be beyond the scope of this introduction. However, a few general observations may serve to situate the Petullo collection. The basic American context for collecting self-taught art twenty to thirty years ago was neither the museum nor the gallery but the flea market. Collectors who buy at flea markets tend to differ in certain key ways from collectors who buy at galleries. Given that most of the work on display at a flea market is uninteresting, buyers are constantly searching for the special object, the one that stands out amid the dross. Whereas exhibitions at galleries entail a culling and pre-selection on the part of the dealer, in the flea market arena it is the collector who does the culling. The decision to buy is based on the collector's immediate visceral response and cumulative collecting experience, but in most situations the flea market collector does not have an opportunity to compare an individual piece to a larger body of work by the same artist. The monographic publications and exhibitions on outsider artists that exist today were not available to the earliest collectors of outsider art.

The thrill of the hunt was certainly a great part of the appeal that collecting outsider art held for its original aficionados. The search that began at roadside junk shops eventually expanded to include encounters and visits with artists. The authenticity of these encounters—the certification that the work and its maker were "for real"—was often as important, and sometimes more so, than the aesthetic perfection of the object. Works could, on occasion, reveal a meaning in situ that they lost immediately upon installation in a collector's home or, later on, in a museum. Conversely, repositioning outsider art in new surroundings might effect a more constructive alchemy, turning the proverbial lead into gold. While certain outsider art collectors lived in homes as cluttered and dusty as junk shops, as the field gained in sophistication museum framing and halogen spot-lighting transformed the objects into something they were never meant to

be: works of modern art. There was (and remains) a genuine conflict between the original context of these objects—as material evidence of a particular cultural environment—and their conversion into high art.

Mainstream artists are active participants in an ongoing art-world dialogue conducted in partnership with dealers, collectors, critics, curators, art historians, and other artists. Self-taught or outsider artists, by definition, are incapable of taking part in that dialogue and therefore enter the discussion not of their own volition but solely at the election of the other participants. Whereas in mainstream art there is always a conscious exchange between the artists and the art-world players who do the choosing, in the field of self-taught art the choosers are in total control. And very often the selection criteria used by these choosers has more to do with the choosers' own agenda than with the makers' original intentions. The artists' relative passivity is yet another reason why collectors have played such an exceptionally powerful role in shaping the field of outsider art.

As collections of outsider art began to coalesce in the 1970s and 1980s, various agendas came to the fore. The flea market route tends to yield collections dominated by three-dimensional work: extensions of nineteenth-century folk-craft traditions (e.g., face jugs, tramp-art boxes made from popsicle sticks); utilitarian objects endowed with extraordinary artistic verve (e.g., shop signs, weathervanes, cigar-store Indians); and creations turned out by eccentric hobbyists (e.g., fanciful whirligigs). The quest for unique artistic encounters led to the discovery of bizarre, self-contained environments, such as the Possum Trot doll world assembled as a tourist attraction by Calvin and Ruby Black, or the evangelical religious garden constructed by the Reverend Howard Finster. Particularly in the African-American community, there were a number of people who made homespun paintings or carvings to express their religious faith. And then there were the "pure" picture-makers: from the homeless Bill Traylor (p. 162), who created brilliant, iconic drawings with the detritus found on the streets of Montgomery, Alabama, in the late 1930s and early 1940s, to the reclusive misanthrope Henry Darger (p. 38), who authored a massive pic-

torial narrative in the solitude of his humble rented room on Chicago's North Side. Many artists died before their work was discovered, while others lived to reap the rewards of newfound careers, thereby inevitably raising questions about exploitation and compromised creative authenticity.

The growth of individual outsider collections was paralleled by the growth of commercial galleries specializing in these artworks. Many of today's outsider dealers originally came out of the flea market and antiques world. They were, at the start, "pickers"—that is to say, people who made the rounds of country auctions and such looking for special objects and then marking up the prices for resale. As living artists entered the mix, the dealers showed their work as well; after all, not every collector wanted to take the trouble to track down artists in the field. The presence of outsider galleries in major cities such as New York, Philadelphia, and Chicago made this type of art accessible to a wider group of collectors. While certain dealers displayed decided proclivities—for example, Phyllis Kind in New York and Chicago leaned more in the direction of *art brut,* while Ricco/Maresca in New York showed both two- and three-dimensional works, including utilitarian objects such as weathervanes—in the aggregate the dealer field was as far-ranging as the collector field, and it covered more or less identical ground.

In the overall context of the American outsider art world, Anthony Petullo may be termed a "second-generation" collector. Unlike those of the first generation, he has had access to a small cadre of dealers and even an occasional museum advisor (such as Russell Bowman, director of the Milwaukee Art Museum), and he has been able to rely on these more experienced professionals for information as well as access to a broader variety of materials than he could possibly have located on his own. Petullo has not felt the need to search for treasure amid the jumble of the flea market (in fact, flea markets hold little appeal for him), and while he has met his share of self-taught artists, personal encounters are not the key to his collecting process. Instead, he prefers to exercise his eye by plowing through a vast body of work by one artist (as he has done on many occasions, both in galleries and at the homes of collectors), eventually emerging with

a few seminal works. Especially in the beginning, he accepted suggestions from such people as Russell Bowman and from the British art dealer Alex Gerrard, but the ultimate decision has always been his; he never makes a purchase using someone else's shopping list.

As Petullo is quick to point out, a collection such as his could never have been formed single-handedly: it is too far-ranging in scope, including European as well as American work and is made up of many pieces by artists who are no longer living. The two cornerstone artists of his collection, in his view, are Alfred Wallis (p. 175) and Bill Traylor (p. 162), one British and the other American. While most Europeans would probably classify Wallis as a naïf, and Americans generally place Traylor among the outsiders, Petullo's pairing of these two—both of whom created iconic but basically representational images—makes aesthetic sense.

At the more *brut* end of the spectrum, Petullo's collection is anchored by the Martin Ramirez (Mexican, p. 150) and Adolf Wölfli (Swiss, p. 191), both of whom were institutionalized mental patients. His tastes are also somewhat skewed in favor of European material, possibly because it is often more pictorially complex than its American counterpart and because European work has been more accessible to Petullo's friend and principal guide, Alex Gerrard. Most (though not all) of Petullo's choices can be found in Dubuffet's museum, but the work of a few artists, such as Max Raffler (German, p. 146), James Lloyd (British, p. 102), and Poland's great self-taught artist Nikifor (p. 134), have been irretrievably claimed by the naive camp. Although the artists whose works Petullo has collected span the entire twentieth century and both sides of the Atlantic, most did not receive substantive recognition until after World War II, and the collection as a whole definitely reflects contemporary tastes. The first-generation naives who came to the fore prior to World War II are scarcely represented.

Petullo's collection is very much of its moment and makes no attempt to be encyclopedic, being as noteworthy for the things omitted as for those included. For example, he has never much been attracted to three-dimensional work, and one finds in his home none of the rough-hewn, quirky crafts objects that figure so prominently in many formative American collections of out-

sider art. The predilection for a refined aesthetic extends to his taste in two-dimensional art as well: certain artists who have been popular with other collectors (e.g., Thornton Dial, Sam Doyle, Howard Finster, Sister Gertrude Morgan, and Mose Tolliver) are simply too *brut* to fit in here. Petullo feels no compunction to own works by these artists; he only buys pieces that genuinely move him.

Like most collectors, Petullo finds it difficult to put his selection criteria into words, for his is an emotional response that almost defies rational description. It is nonetheless an informed response, and there are certain overriding sensibilities that unite the objects in the collection. His preference for two-dimensional work stems from a profound appreciation of the craft of picture-making. Most of the works in the collection are tightly structured, either through dense patterning—as in the works by Minnie Evans (p. 49), Martin Ramirez (p. 150), Joseph Yoakum (p. 194), Johann Garber (p. 60), Madge Gill (p. 64), Scottie Wilson (p. 182), and Adolf Wölfli (p. 191)—or a lushly worked paint surface—as in the works by Alfred Wallis (p. 175), John Serl (p. 156), William Hawkins (p. 68), and Justin McCarthy (p. 125). Though self-taught, the artists instinctively muster an impressive array of techniques: Eddie Arning (p. 28), for example, is a master of negative space; Henry Darger (p. 38) orchestrates magnificent color harmonies over his mural-length panels; Friedrich Schröder-Sonnenstern (p. 152) renders his fantasmagorical creatures in meticulous detail.

There are many ways of looking at self-taught art—as expressions of a particular community's culture, as throwbacks to a preindustrial craft tradition, as manifestations of personal idiosyncrasy—but it is clear that Anthony Petullo looks at this work, first and foremost, as art. This is not to say that the romance of the artists' stories holds no appeal for him. Every collector of self-taught art has at some point made a deliberate decision to favor this type of work over more mainstream efforts. For the Europeans, from Picasso to Dubuffet, the decision was prompted by the conviction that mainstream art had grown stale and that only the untrained were still tapped into the primordial sources of creative expression. American partisans of self-taught art, both in

the first and the second halves of the last century, tended to give the European theory a more egalitarian, democratic twist: self-taught art was equated with the individual empowerment that lies at the heart of the American Dream.

It is no coincidence that for many years Petullo ran a temporary and contract staffing company and that his collection originally adorned the walls of his company's headquarters in Milwaukee. He is a humanist, and just as his company empowered people by giving them jobs, his collection proclaims the right of any individual to make art. In their struggles to overcome adversity, these self-taught artists personify the Horatio Alger parable: most of them led difficult lives, yet they still managed to produce work of transcendent beauty. Privileging their work over and above that of trained artists also entails a rejection of the centralized authority of alleged art-world sophisticates. The moral of the story is not only that anyone can make art but that anyone can appreciate and collect it. From this perspective, the fact that the outsider field did not have the art world's seal of approval in the 1970s and 1980s was pivotal to its appeal and hence to its growth.

At first glance, it may seem paradoxical that a collection such as Petullo's, which is so quintessentially American in motivation, should be so international in content. In part, this internationalism may be due to a typically American generosity of spirit: the at-times naive tendency that some Americans have to assume that human universals invariably transcend national cultural differences. However, by eschewing the provincial chauvinism that characterizes most other American outsider art collections, Petullo accurately reaffirms the original connection between *art brut* and outsider art. His selection criteria provide a very cogent synthesis of the historical continuum that lies at the heart of the self-taught field as a whole.

Consciously or not, Petullo has selected examples of American outsider art that complement or reflect an extension of European sensibilities. In avoiding three-dimensional work, he instinctively recognizes that these objects belong to a different tradition, more influenced by craft and folk art, less concerned with the art of picture-making per se. He has chosen to focus on the

strength of individual expression rather than on works that bespeak a more communal or religious orientation. In this he seems far ahead of many aficionados of self-taught art who tend to throw these disparate works into the same pot.

Petullo's high aesthetic standards impart another important lesson sometimes overlooked by partisans of self-taught art: namely, quality *does* count. When self-taught art is viewed purely as evidence of material culture or as illustrations for exceptionally sordid biographies, issues of quality can become obscured and folklorists or psychiatrists may legitimately feel no need to pay attention to quality. However, the fact that self-taught art can and does serve several masters does not countermand its right to be taken seriously as art. The best self-taught artists are fully the equal of their trained colleagues, though this becomes evident only when their work is consciously culled from the mediocre majority. If tastes are variable and the definition of quality subject to constant revision, the process of culling does not change much. Repeated viewing trains the eye, and "better" can be distinguished from "worse" only when one has seen an ample sampling of comparable works.

This is the service that Anthony Petullo—and every serious collector—performs for the rest of us. Self-taught art has thus far always been a field defined in the negative, as everything that mainstream art is not. However, the individual works and their makers do have their specific histories, both in and of themselves and within the art world that anointed them and gave their work a larger meaning. If and when self-taught art becomes a fully mature field of scholarly study, the various types of work that have been lumped together in the nonacademic category will have to be untangled and restored to their original contexts. It will probably turn out that self-taught art is not one field at all but a mass of different fields, each with a distinctive trajectory of its own. The Anthony Petullo Collection, unified by an especially compelling point of view, provides an important contribution to the ongoing dialogue about the nature and history of self-taught art.

NOTES

1. For the purposes of this introduction, the term "self-taught" is used in the broadest sense to cover the full range of works in Petullo's collection. "Self-taught" is also the most neutral and comprehensive of the various designations commonly used to designate Western art made outside the boundaries of the artistic mainstream. However, the term has its limitations: for one thing, not every artist who falls into this category is completely self-taught; and second, there are artists (e.g., Vincent van Gogh) who, though self-educated, do not belong in this group. As is discussed in the course of the introduction, the term "outsider," if used correctly, applies to a narrower segment of artists within the self-taught contingent. It is used here to refer specifically to the European *art brut* group and their American counterparts.

2. Wassily Kandinsky and Franz Marc, eds., *Der blaue Reiter Almanac* (Munich: R. Piper and Co., 1912).

3. Uhde's Sacred Heart Group included the French artists André Bauchant, Camille Bombois, Séraphine Louis, Henri Rousseau, and Louis Vivin.

4. Among the American self-taught artists who achieved recognition between 1927 and the early 1940s are Morris Hirshfield, John Kane, Lawrence Lebduska, Israel Litwak, Grandma Moses, and Horace Pippin.

5. Grandma Moses had her first one-woman exhibition in 1940 at the age of 80; she died in 1961 at the age of 101. Her fame grew considerably over the course of her twenty-year career.

6. In the beginning, Dubuffet was drawing on the work of Hans Prinzhorn, a psychiatrist who in the early 1920s had established a massive collection of work by mental patients at the Heidelberg Psychiatric Clinic in Germany. Following the publication of Prinzhorn's landmark book *Bildnerei der Geisteskranken* (Artistry of the Mentally Ill) (Berlin: Springer Verlag, 1922) the art of the mentally ill was embraced by a number of avant-garde artists in tandem with the ongoing investigation of disparate nonacademic art forms. However, during this period psychiatric art never attained the broad popularity of naive art.

7. The Collection de l'Art Brut in Lausanne, Switzerland, was established in 1976.

8. This foray into art dealing was not particularly successful and did not last long: Petullo's Milwaukee gallery was in operation only from 1982 to 1984.

9. Jean Lipman and Alice Winchester, *The Flowering of American Folk Art, 1776–1876* (New York: Viking, 1974), 9.

10. During his tenure as curator at the Museum of American Folk Art (then tellingly called the Museum of Early American Folk Art) in the late 1960s and early 1970s, Herbert Waide Hemphill Jr. organized several

ground-breaking exhibitions of twentieth-century self-taught art. However, the museum did not make a formal commitment to this area until 1997, when it established its Contemporary Center.

11. Probably the most seminal collectors of American self-taught art in the second half of the twentieth century were Michael and Julie Hall (whose collection is now housed at the Milwaukee Art Museum) and Herbert Waide Hemphill Jr. (whose collection went to the Smithsonian American Art Museum). These collectors, who often traveled together, favored the flea market route and had a strong predilection for three-dimensional work. Together with Julia Weissman, Hemphill wrote the first basic guide to the emerging "outsider" field: *Twentieth-Century American Folk Art and Artists* (New York: E. P. Dutton and Co., 1974).

12. Important early collectors of American self-taught art include Abbey Aldrich Rockefeller, Duncan Phillips and Albert Barnes. All of them formed collections (the latter two revolving principally around the avant-garde mainstream) that are today housed in eponymous museums.

THE ARTISTS AND THEIR ART

CONSUELO "CHELO" GONZÁLEZ AMÉZCUA (1903–75)

CONSUELO AMÉZCUA was born in Piedras Negras, Mexico, and moved with her parents to Del Rio, Texas, when she was ten years old. She began drawing at an early age and was the recipient of an art scholarship to the San Carlo Academy in New Mexico. She was unable to attend, due to her father's death, and remained professionally untrained. Her drawings consist of central figures surrounded by complex and intricately detailed patterns. Although she experimented with more traditional pen and ink, she preferred the clean lines of a ballpoint pen. Amézcua's iconography includes images from the Bible, ancient Mexican folklore, and classical myths.

1 QUEEN OF SHEBA, 1967 • Ballpoint pen and pencil on paper • 28 x 22 in. (71.1 x 55.9 cm)

The text within the image reads:

LEGEND OF THE SEED

2 LEGEND OF THE SEED, 1974 · Ballpoint pen and pencil on paper · 22 × 14 in. (55.9 × 35.6 cm)

3 THE PROPHECY, 1966 · Ballpoint pen and pencil on paper · 20 x 30 in. (50.8 x 76.2 cm)

4 THE ASTRONAUT FILIGREE LADY, 1971 · Ballpoint pen and pencil on paper · 22 x 14 in. (55.9 x 35.6 cm)

5 GOD CREATED THE HEAVENS AND EARTH, 1968 · Ballpoint pen and pencil on paper · 28 x 22 in. (71.1 x 55.9 cm)

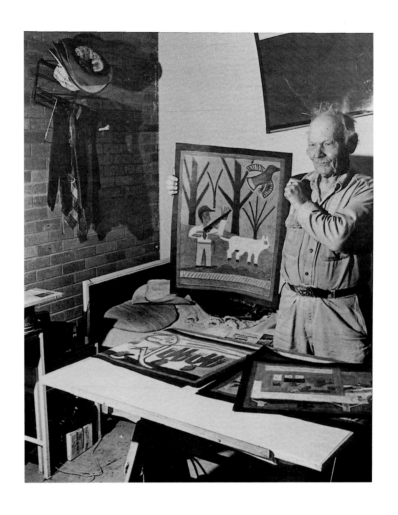

EDDIE ARNING (1898–1993)

THROUGHOUT his childhood, Eddie Arning worked on his family's farm in Texas. He experienced bouts of mental illness while in his twenties and in 1934 was committed by his parents to Austin State Hospital, where he remained for thirty years. He began drawing in 1964 while attending a hospital art class and developed his artistic talent over the next ten years. Arning was encouraged by his long-time friend Alexander Sackton, who supplied him with materials and cataloged and stored his drawings as they were completed. Arning moved to a comfortable nursing home, supporting himself through the sale of his drawings. In 1974 he stopped drawing and went to live with his sister. He returned to the nursing home three years later, remaining there until his death. Much of his subject matter came from the advertisements and illustrations he saw in popular magazines. His drawings are not simple copies, however, but unique interpretations of their sources. The heavy patterning and vibrant colors demonstrate a disregard for naturalism, a common trait among outsider artists.

EDDIE ARNING was an unremarkable patient at Austin State Hospital, quiet and submissive to the complete authority of the institutional system. One day he attended a mandatory art class taught by Helen Mayfield, a strikingly beautiful young woman with vibrant energy and enthusiasm. An occasional patient at the hospital, she knew that art could be a wonderful diversion and volunteered to teach a class.

For many days Arning sat in class with a blank sheet of drawing paper and crayons before him. Even with Helen's gentle encouragement he could not make marks on that paper. So she gave him a coloring book. He liked that—filling in the predetermined shapes with colors that delighted him. After he had worked through ten or more coloring books, Helen told him that he should draw a picture on his own, which he did. Slowly, carefully, . . . happily! Eddie Arning had discovered magic. The ten years following his release rolled by as he filled his days drawing pictures, living the life of a visual adventurer, immersed in a new world.

—PAMELA HILL, art gallery owner

7 WOMAN AND MARTINI & ROSSI, 1972 · Oil crayon on paper · 20 x 26 in. (50.8 x 66.0 cm)

8 Reference material for WOMAN AND MARTINI & ROSSI, from an unknown magazine

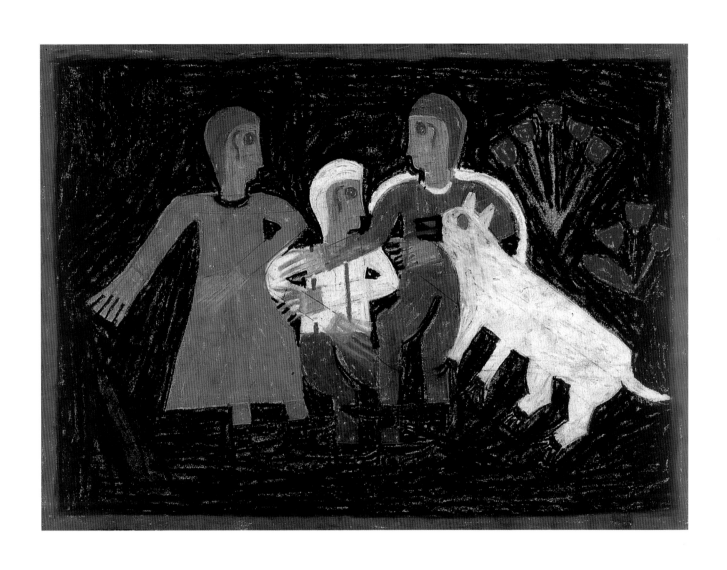

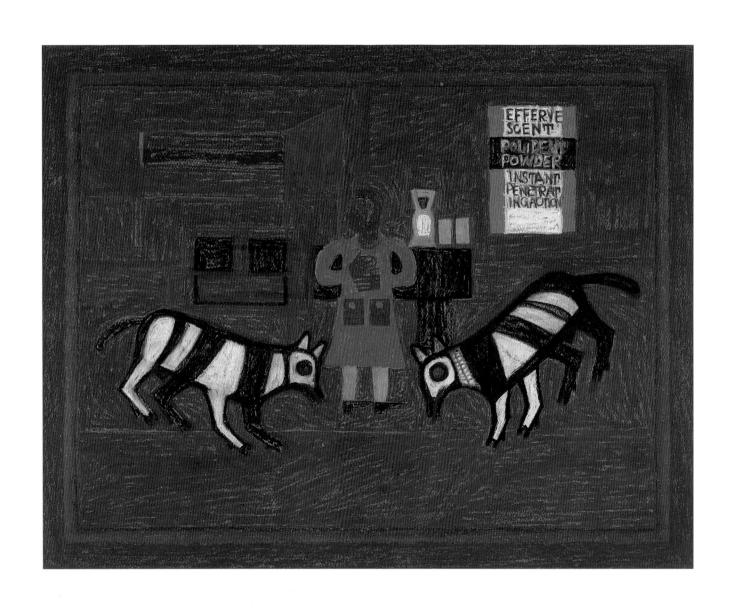

The text visible in the image reads:

EFFERVE
SCENT

POLIDENT
POWDER

INSTANT
PENETRAT
INGACTION

10 WOMAN, TWO DOGS, POWDER, 1968 • Oil crayon on paper • 22 x 28 in. (55.9 x 71.1 cm)

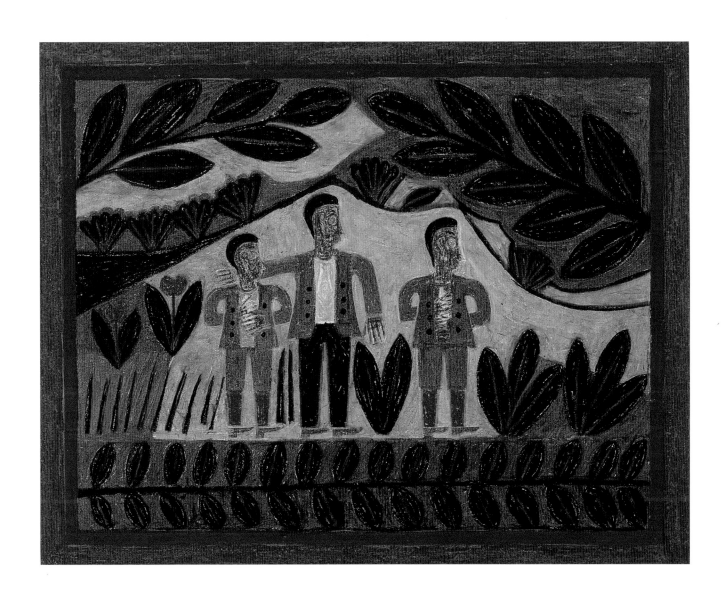

11 THREE MEN AT DUSK, 1964 · Oil crayon on paper · 23 x 29 in. (58.4 x 73.7 cm)

CARLO (CARLO ZINELLI) (1916–74)

BORN IN San Giovanni Lopatoto, Italy, Carlo was sent to work as a farm laborer at the age of nine. He moved to Verona when he was fifteen to become a butcher's apprentice, and in 1936 he was conscripted into the Italian army. It was during his military service that he first began showing symptoms of mental illness, attacking his captain in a fit of anxiety. Carlo's mental condition worsened after his discharge in 1941, with incidents of hallucinations and the development of a persecution complex. In 1947 his family committed him to the San Giacomo Psychiatric Hospital in Verona, where he began drawing on the walls with a brick. A decade later, in 1957, a Scottish sculptor named Michael Noble convinced the hospital to provide an art studio for the patients, and Carlo painted there every day for the next fourteen years. His paintings are crowded with images in no apparent spatial relation to one another. Human figures and animals are among the images that are repeated, often in groups of four. After San Giacomo was closed in 1971, Carlo was transferred to another Verona hospital and his creative activity diminished. Eventually he was released to his family and died of tuberculosis.

12 UNTITLED, 1967 · Tempera on paper, double-sided · 27⅜ × 19⅝ in. (70.6 × 49.9 cm)

13 UNTITLED, n.d. • Tempera on paper, double-sided • 27⅜ × 19⅝ in. (70.6 × 49.9 cm)

14 UNTITLED, n.d. • Tempera on paper, double-sided • 19⅝ x 27⅞ in. (49.9 x 70.6 cm)

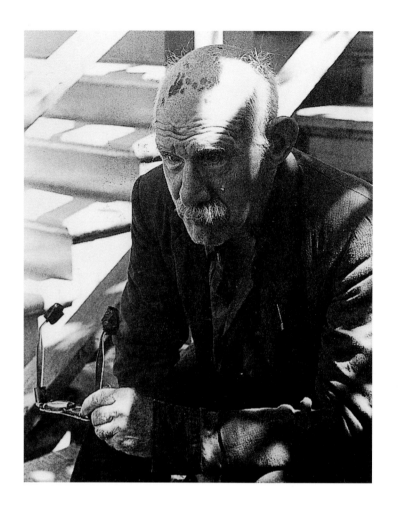

HENRY DARGER (1892–73)

HENRY DARGER was eight years old when his father, with whom he lived in Chicago, was crippled and could no longer care for him. He was sent to a Catholic boy's home and later, after exhibiting behavioral problems, to an asylum. Darger ran away in 1908 and over the next forty-eight years worked as a janitor in various hospitals. He was an eccentric man who went to church obsessively and had very little contact with other people. In 1911 he began writing *In the Realms of the Unreal*, his epic saga of an imaginary world in which a brutal war was fought between nations over the enslavement of children. He illustrated the 15,145-page typescript on enormous sheets of paper ranging from six to twelve feet in length. The drawings are sexually charged and include graphic depictions of violence in which children, particularly young girls, are slaughtered by the evil Glandelinians. In addition to his freehand drawings, Darger also traced many of his images from coloring books, magazines, photographs, and comic books. His work was discovered by his landlord, the photographer Nathan Lerner, after Darger retired to a nursing home in 1973.

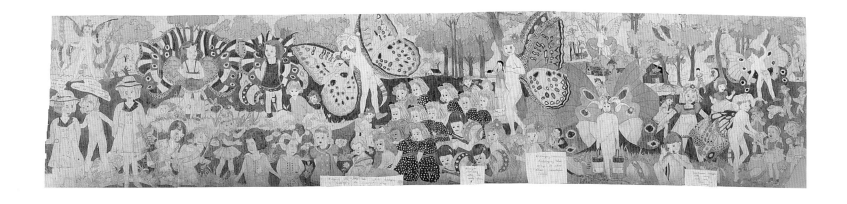

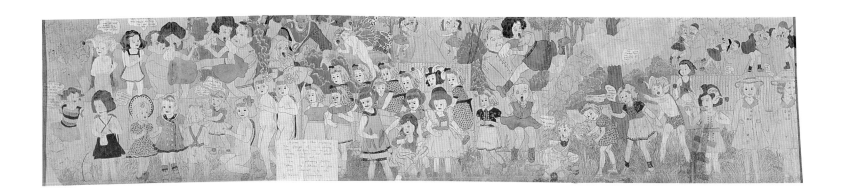

16–17 BLENGIGLOMENEANS DISPLAYING THEIR WINGS (recto) · IMAGES OF MEN STRANGLING CHILDREN (verso), n.d.

Watercolor, pencil, carbon, and collage on paper · 24 x 109 in. (61.0 x 276.9 cm)

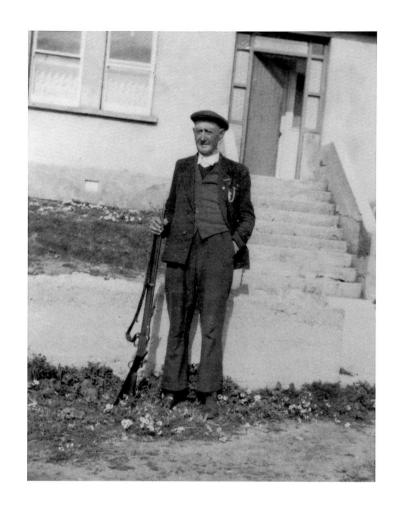

JAMES DIXON (1887?–EARLY 1970S)

JAMES DIXON was born on Tory Island, a small, remote piece of land off the rugged northwest coast of Ireland. He lived there all of his life, rarely venturing onto the mainland, and began painting as a means of occupying his time. His unorthodox painting methods included fashioning brushes from the hairs of a donkey's tail and using boat paint salvaged from the trash. Around 1960 Dixon's work came to the attention of the artist Derek Hill, who had a cottage on Tory Island. Hill encouraged Dixon to continue his artistic activities and supplied him with more conventional art supplies. His images of the sea, boats, and wind were rendered with force through wild, expressionistic brush strokes and thickly applied paint. His limited palette rarely varied from black, gray, green-gray, and blue-gray, accurately portraying the color of his life on the island.

DEEPLY LOYAL to the Tory Island community, Jimmy Dixon lived with his three brothers and his sister, Grace, in a two-story house in Westport. My first memory of the family is of a day in 1953 when Hughie Dixon brought me ashore after a rough passage. Grace warmly welcomed us, dried our wet clothes, and revived us with tea and soda bread baked in a pot over the fire.

That evening, after flattened cardboard boxes were lifted from the floor and water was sprinkled to stop the dust from rising, we danced Irish reels, including the favorite "Waves of Tory," accompanied by a snappy fiddle. Jimmy sang with great feeling and retold old legends, passed down from generations, like the story of Balor the evil one-eyed giant. His translation from the Gaelic, recited with closed eyes and vivid descriptions, gave the impression that these events had occurred just last week.

A man of versatility, Jimmy was also a reader, rifle-shooter, and taxidermist. He harvested crops with a sickle and made model boats, a jeweled walking stick, and jewelry. Often, when a fierce gale would rage for days on end, he would go to his workshop and produce dramatic pictures. Above all, Jimmy had a deep Christian faith. His kindly philosophy still encourages me today. As well as being a true artist, he was a resilient, resourceful, perceptive, and kind-hearted man.

—JILL LIVSEY, friend

I MET James Dixon on my first visit to Tory Island in 1956. I was painting near the harbor, and he and several islanders came to watch. "I can do better than that," he remarked, to which I replied that he should paint a picture and show it to me. I provided him with paints and paper, which he preferred to canvas. He said he made his own brushes out of his donkey's tail hairs.

"This is a good one," he used to say when he showed me what he'd done. Often the paintings he sent to my house on the mainland were still wet when they were rolled up and placed on the mail boat for delivery. During the crossing they became even wetter with sea spray, and some were ruined when they arrived.

When Dixon came to visit me, he would smile as he walked in and saw some of his pictures facing him. However, when he sat down for tea and looked in the other direction, his face would cloud over as he saw the works of his rival and close neighbor, Jimmy "The Yank" Rogers.

Dixon's studio was an incredibly untidy, dusty, even dirty cottage room next to where his family lived. His paint got onto everything. He smoked a pipe as he painted, looking like a true artist at work. He didn't talk much, so I never had any long conversations with him. His pictures never needed explaining. What they represent was always written on the picture in his own handwriting.

—DEREK HILL, artist, collector, and friend

19 GREENLAND OWL, 1967 · Oil on paper · 12 x 9 in. (30.5 x 22.8 cm)

20 COTTAGES COVERED WITH SPUME, 1965 · Oil on board · 19 x 23 in. (48.3 x 58.4 cm)

21 ARLIN POINT, 1966 · Oil, pencil, and ink on board · 22 x 29½ in. (55.9 x 74.9 cm)

22 LOVING CUP, 1964 · Oil on paper · 20 x 14 in. (50.8 x 35.6 cm)

23 THE PHEASANT, n.d. · Oil on paper · 13½ x 16 in. (34.3 x 40.6 cm)

24 PORTRAIT OF WALLACE CLARK, n.d. · Oil on paper · 20 x 14 in. (50.8 x 35.6 cm)

25 WEST END VILLAGE, TORY ISLAND, 1964 · Oil on board · 22 x 30 in. (55.9 x 76.2 cm)

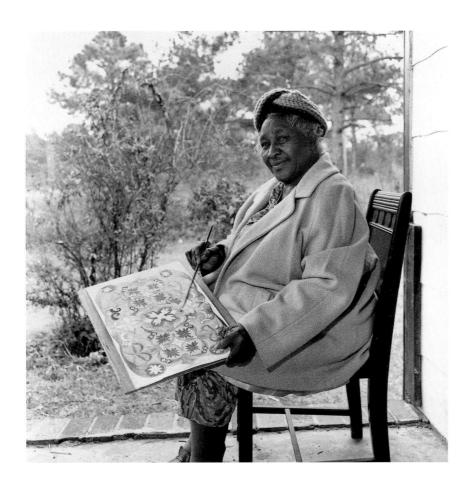

MINNIE EVANS (1892–1987)

BORN IN Long Creek, North Carolina, into a family who traced their origins to Trinidad, Minnie Evans worked for many years as a domestic and later became the gatekeeper at Airlie Gardens near Wilmington. She recounted that in 1935 she received a direct command from God to draw. As a result of this powerful spiritual experience, she began to draw pictures based on the strange dreams and religious visions that had haunted her since childhood. Evans painted for the next fifty years, selling her art to those who visited Airlie Gardens. Her work features images such as flowers, plants, birds, and angels intricately woven together in lush colors.

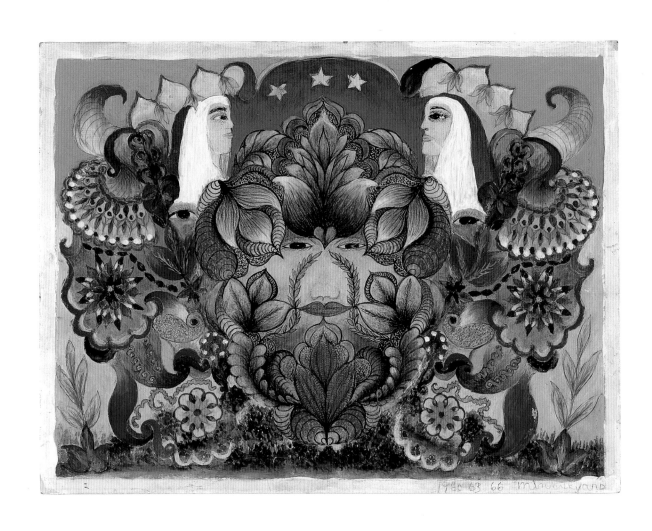

26 UNTITLED, 1960, 1963, 1966 · Mixed media on paperboard · 15 x 20 in. (38.1 x 50.8 cm)

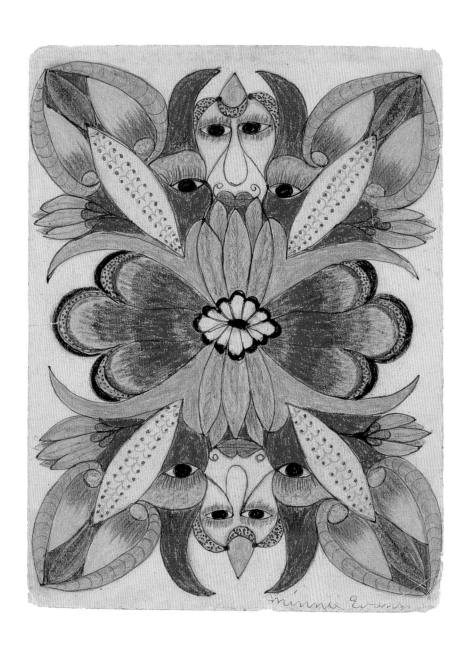

27 UNTITLED, ca. 1946 · Pencil, colored pencil, and ink on paper · 12 x 9 in. (30.5 x 22.9 cm)

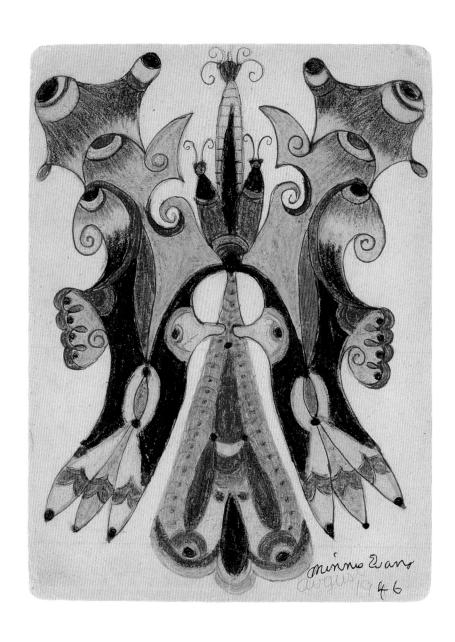

28 UNTITLED, 1946 • Pencil and crayon on paper • 12 x 9 in. (30.5 x 22.9 cm)

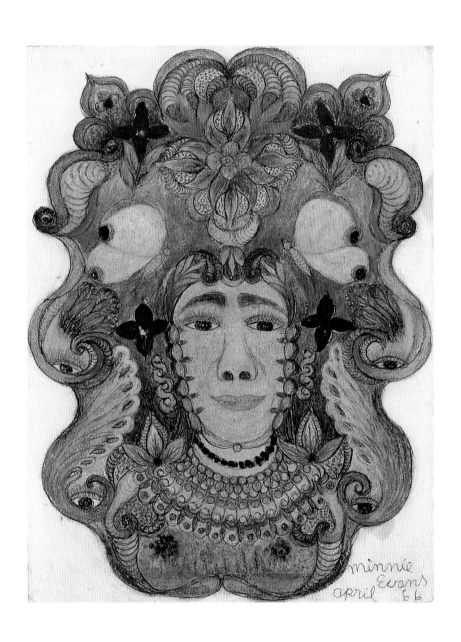

29 UNTITLED, 1966 · Crayon, gold paint, and oil paint on paper · 12 x 9 in. (30.5 x 22.9 cm)

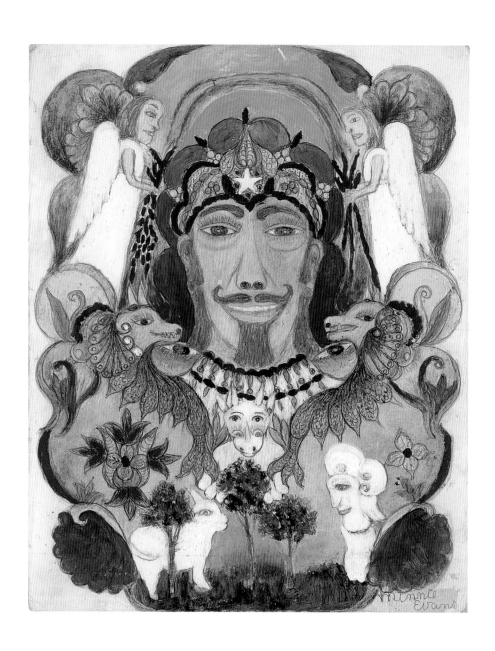

30 UNTITLED, 1964 · Oil and pencil on paper · 14 x 11 in. (35.6 x 27.9 cm)

JOHANN FISCHER (B. 1919)

JOHANN FISCHER, one of seven children of an Austrian farming family, received only an elementary education. He worked as a baker before being conscripted into the German army in 1940. Captured by American troops and eventually released in 1946, Fischer received psychiatric care for the first time in 1957 as a result of delusionary episodes. In 1961 he was permanently committed to the Klosterneuburg Hospital, more commonly known as Gugging, located near Vienna. He began drawing in 1981, having been influenced by the artists living in the recently opened Haus der Künstler (Artists' House), which was located on the hospital grounds and housed patients with exceptional artistic talent. Initially he drew single images, but his compositions have become more complex over the years. His preferred tools are pen and colored crayons. Since the mid-1980s he has included text in his drawings as a further explanation of his images. Fischer has been living in the Haus der Künstler since 1982.

7. Oktober 1986

31 THE MOUNTAIN MEADOWS, 1986 · Pencil and colored pencil on paper · 15¾ x 11¾ in. (40.0 x 29.9 cm.)

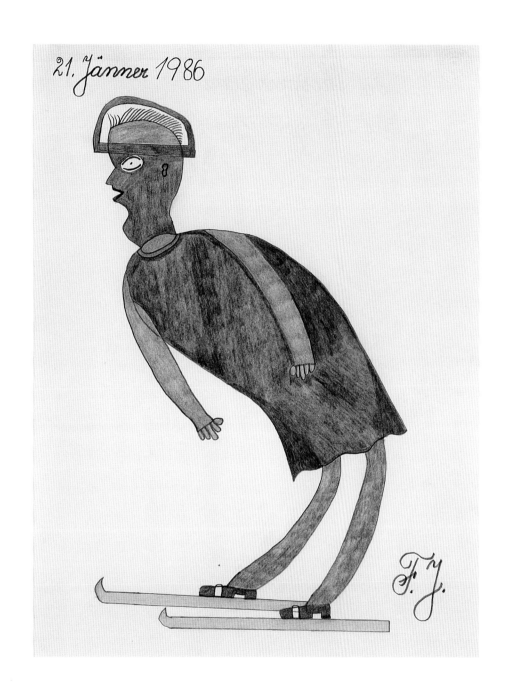

32 WOMAN SKI JUMPER, 1986 · Pencil and colored pencil on paper · 15¾ x 11¾ in. (40.0 x 29.8 cm)

57

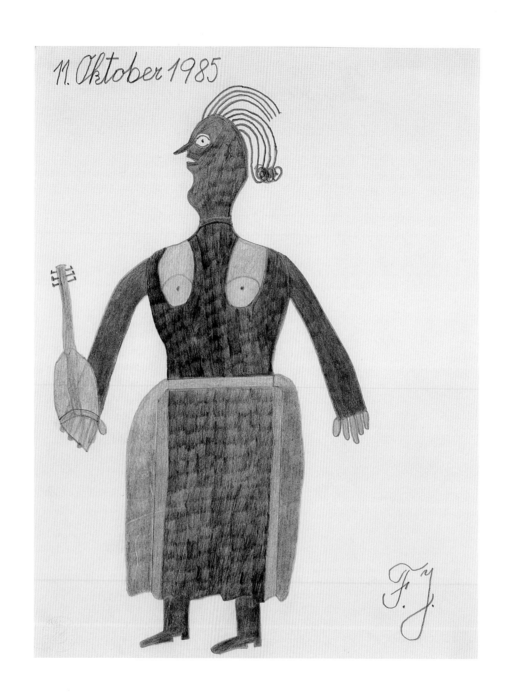

33 MUSICIAN, 1985 · Pencil and colored pencil on paper · 15⅝ x 11¾ in. (39.7 x 29.8 cm)

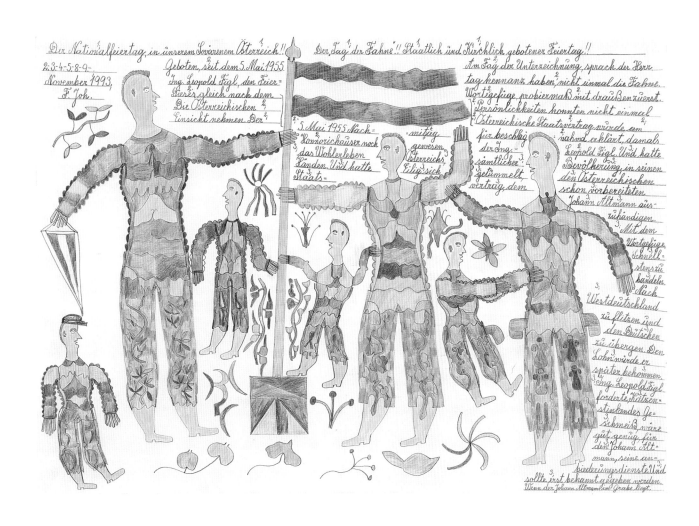

JOHANN GARBER (B. 1947)

ANOTHER of the Klosterneuburg Hospital artists, Johann Garber was born in Austria and has been drawing since 1975. He uses a feather and India ink to create meticulously detailed, often overcrowded compositions that contain a myriad of images (including figures, animals, and trees) and are marked by a pervasive sexual overtone. His painted images, which he began producing in 1983, differ from his drawings in their use of color, more broadly defined forms, and a lack of obsessive detail. Garber's work can be seen throughout Gugging, as he has painted window and door frames there as well as the institution's boiler tank.

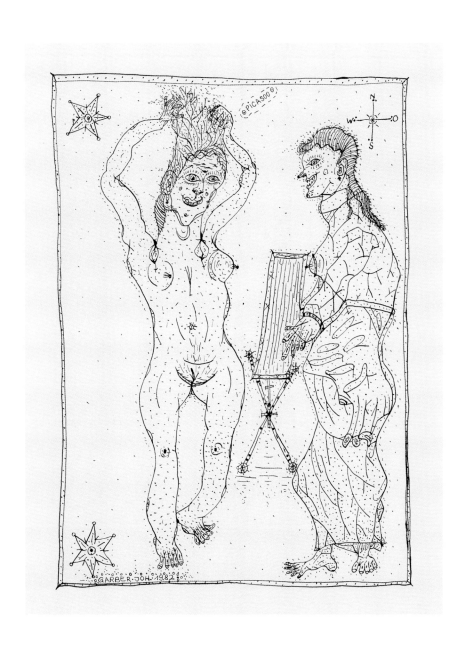

35 PICASOO, 1982 · Ink on paper · 15¾ x 11¾ in. (40.0 x 29.9 cm)

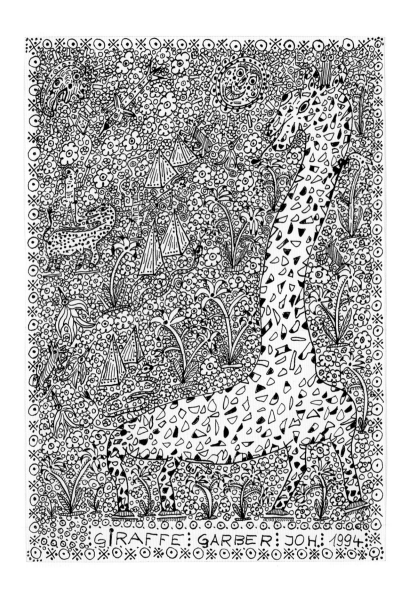

36 GIRAFFE, 1994 • India ink on paper • 11¹¹⁄₁₆ x 8¼ in. (29.7 x 21.0 cm)

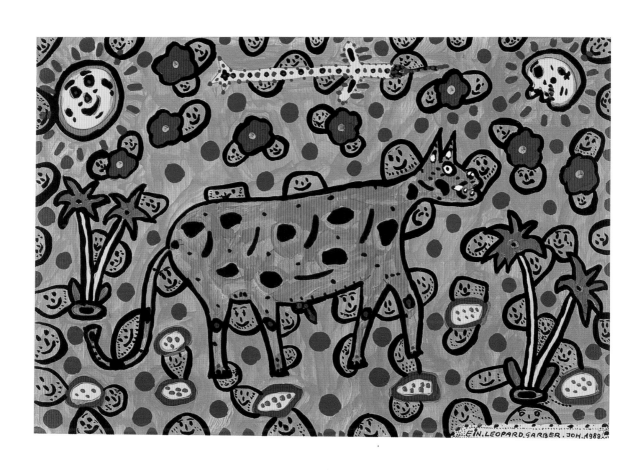

37 LEOPARD, 1989 · Acrylic and gouache on paper · 11¾ x 17¼ in. (29.9 x 43.8 cm)

MADGE GILL (1882–1961)

MADGE GILL (née Maude Ethel Eades) was born in London and placed in an orphanage at the age of nine by her mother. When she was nineteen she worked as a nurse and lived with her aunt, who introduced her to spiritualism. In 1907 she married Thomas Gill and had three children by him, one of whom died in infancy. Gill herself almost died while giving birth to a fourth, stillborn child in 1919, losing the sight in her left eye from the illness that followed. That same year she began a flurry of artistic activity, including drawings that were guided by a spirit she called Myrninerest. She worked on paper or rolled calico, which she unrolled frame by frame, never viewing the composition in its entirety. Her drawings, some of which reach lengths of thirty-five feet, include patterns and designs that obsessively cover the surface. The figure of a young woman dressed in flowing robes appears thousands of times in her works.

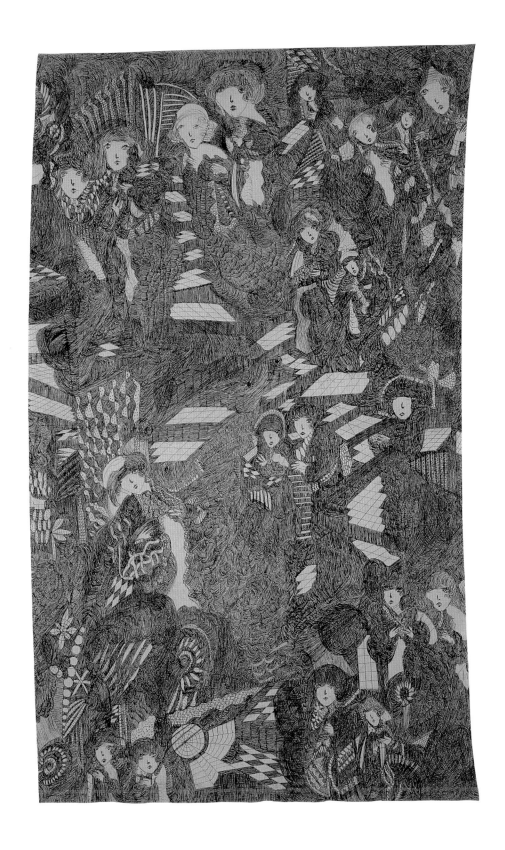

38 UNTITLED, ca. 1930 · Ink on calico · 69½ x 41 in. (176.5 x 104.1 cm)

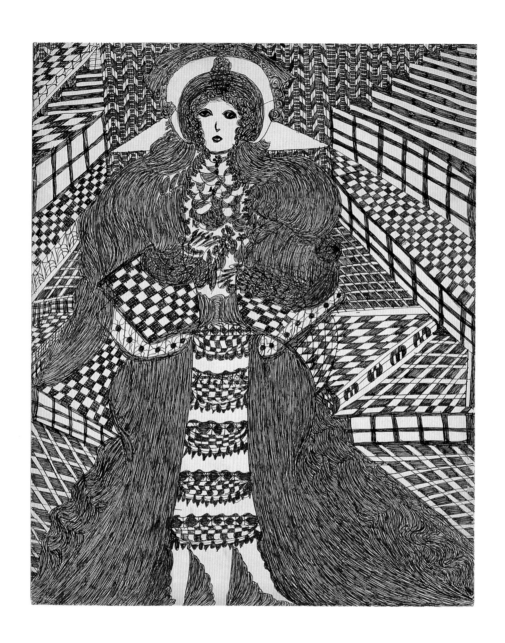

39 UNTITLED, n.d. · Ink on card · 25 x 20 in. (63.5 x 50.8 cm)

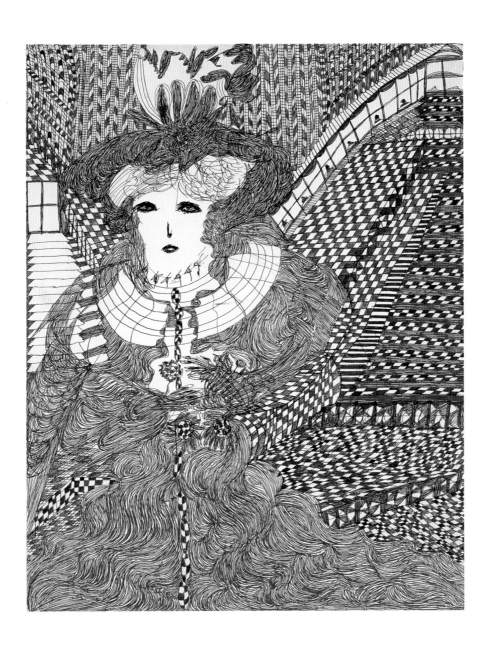

40 UNTITLED, n.d. · Ink on card · 25 x 20 in. (63.5 x 50.8 cm)

WILLIAM HAWKINS (1895–1990)

WILLIAM HAWKINS was born in eastern Kentucky and lived on his grandparents' farm. In 1916 he moved to Ohio, where he married and started a family. He was a construction worker and truck driver before obtaining employment in the 1920s at the Buckeye Steel Casting Company in Columbus. Hawkins began painting in the 1930s, selling his work for whatever extra income it provided. Upon his retirement he was able to devote his full attention to painting. His neighbor, the artist Lee Garrett, noticed his work and brought it to the attention of a New York dealer, Roger Ricco. Garrett also encouraged Hawkins to enter the 1982 Ohio State Fair Art Exhibition, where he won a prize. Hawkins's iconography includes cityscapes, animals, images from frontier America, and current events. His paintings have tremendous texture, which he achieved through the use of impasto and, in later works, collage techniques.

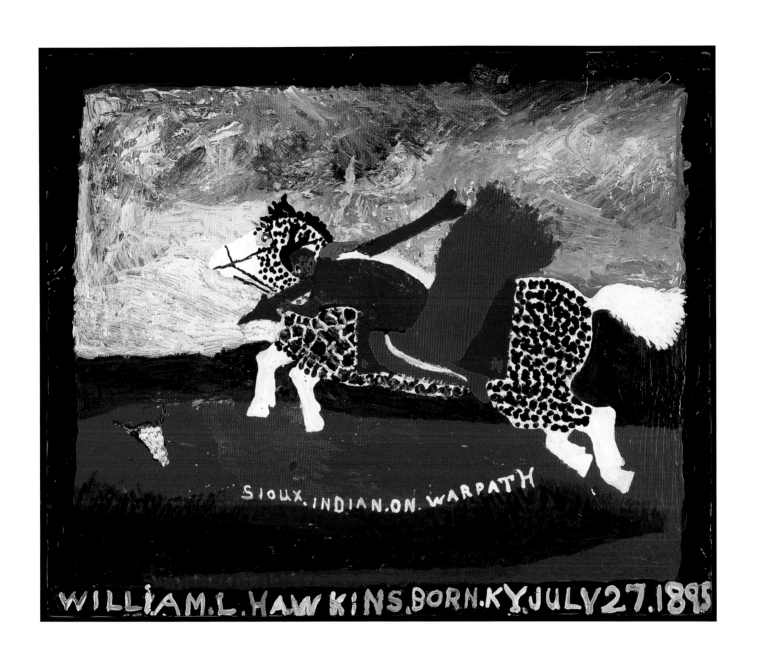

41 SIOUX INDIAN ON WARPATH, 1985 · Enamel on Masonite · 39 x 48 in. (99.1 x 121.9 cm)

69

42 THE EAGLE AND THE SERPENT, ca. 1981 · Oil, bronze paint, and glitter on wood · 30 × 35½ in. (76.2 × 90.2 cm)

43 JUMBO ELEPHANT #3, 1989 · Enamel, wire, tree branch, and nail on Masonite · 48 x 56½ in. (121.9 x 143.5 cm)

PATRICK HAYMAN (1915–88)

THE YOUNGEST of three children born to nonreligious Jewish parents in London, Patrick Hayman began painting in 1938 while living in New Zealand, where he spent long periods of time in remote, isolated places. He returned to London in 1947 to pursue a career as a painter and married a woman from Cornwall in 1950. Shortly thereafter he and his wife, Barbara, visited the northern Cornish fishing town of St. Ives, home to two painters Hayman admired and whose work influenced his: Christopher Wood and Alfred Wallis. The Haymans lived in St. Ives from 1951 to 1953, during which he formed friendships with Wood, Barbara Hepworth, and Peter Lanyon. Certain images such as a bearded rabbinical figure, boats, and crucifixes recur in his work. Hayman's technique of overpainting on heavy layers of white gives his paintings an unusual luminosity as well as a chalky texture.

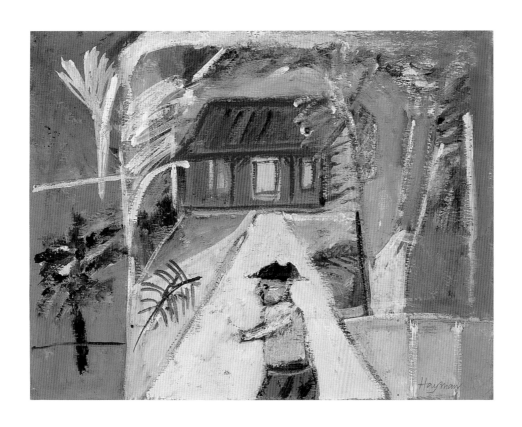

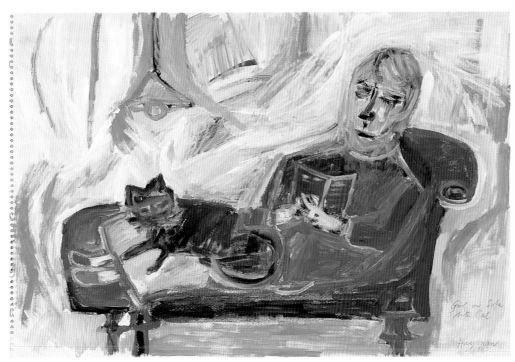

44 THE SETTLER'S HOUSE, 1962 • Gouache on paper • 8½ x 11 in. (21.6 x 27.9 cm)

45 GIRL ON SOFA WITH CAT, 1963 • Gouache on paper • 12 x 17 in. (30.5 x 43.2 cm)

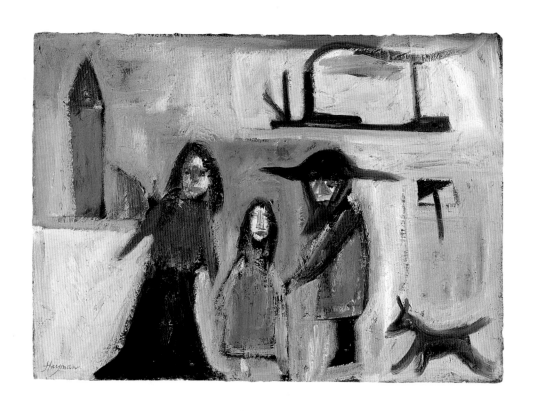

46 FAMILY NEAR THE SHORE, 1981 · Oil on board · 10 x 13½ in. (25.4 x 34.3 cm)

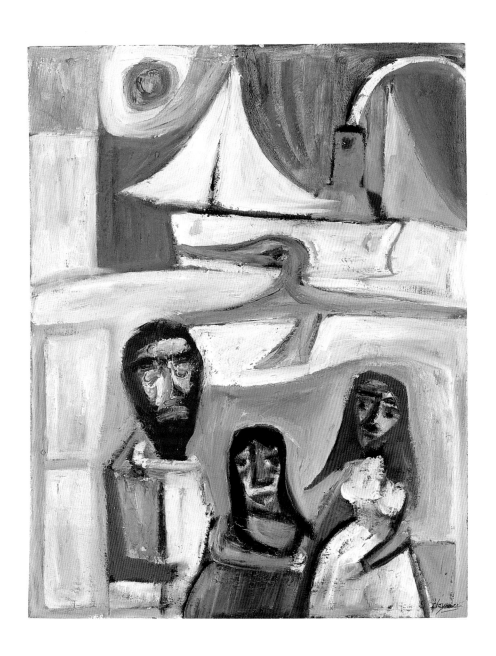

47 IBSEN AND HIS FAMILY, 1980 · Oil on board · 19 x 14 in. (48.3 x 35.6 cm)

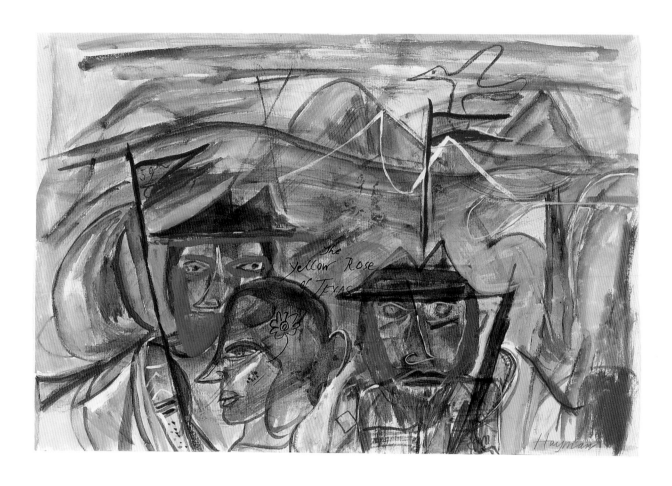

48 YELLOW ROSE OF TEXAS, 1981 · Gouache on paper · 12 x 17½ in. (30.5 x 44.5 cm)

49 MARRIAGE AT CANA, 1987 · Oil on canvas · 29 x 20 in. (73.7 x 50.8 cm)

JOHN KANE (1860–1934)

AT THE AGE of nineteen, John Kane emigrated with his family from Scotland to Braddock, Pennsylvania. He worked mostly as a day laborer until a train accident in 1891 caused him to lose his left leg. Subsequently he found less-strenuous jobs painting houses and boxcars. He also began experimenting with color, painting landscapes and Scottish-themed subjects on discarded boards. In 1927 one of his paintings was accepted at the Carnegie International Exhibition, which served to establish his career as an artist. Kane's work was widely exhibited in Pittsburgh and New York, making him one of the first self-taught artists of the twentieth century to receive critical acclaim in America. His newfound success allowed him to devote the last years of his life entirely to his painting.

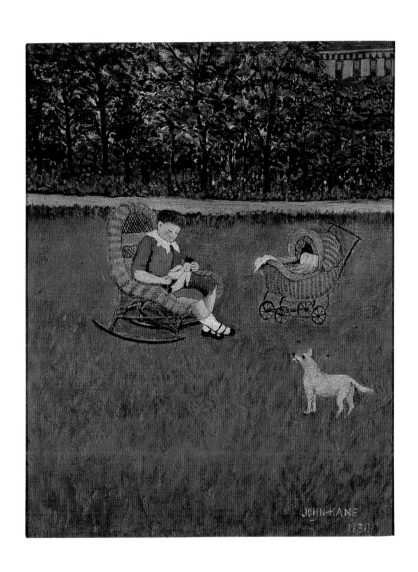

ROSEMARIE KOCZY (B. 1939)

BORN IN Germany, Rosemarie Koczy and her family were imprisoned in a Nazi concentration camp during World War II. Her experiences in the camp, including the killing of her father, became the driving inspiration of most of her work. She eventually studied at the School of Decorative Arts in Geneva and completed advanced residencies in Prague and Rome. In 1965 she began weaving tapestries, for which she would become well known. Frustrated by the limitations of the tapestry medium, she began drawing and painting in 1975. Ten years later Jean Dubuffet selected Koczy's work for a solo exhibition at the opening of the Neuve Invention Annex at his Collection de l'Art Brut museum in Lausanne, Switzerland. Skeletal human figures dominate her drawings, barely emerging from their densely hatched backgrounds, appearing almost too weak to break onto the surface. Koczy says that the creative process is not something she controls; rather, she records the pictorial impulses that come to her, using both hands simultaneously.

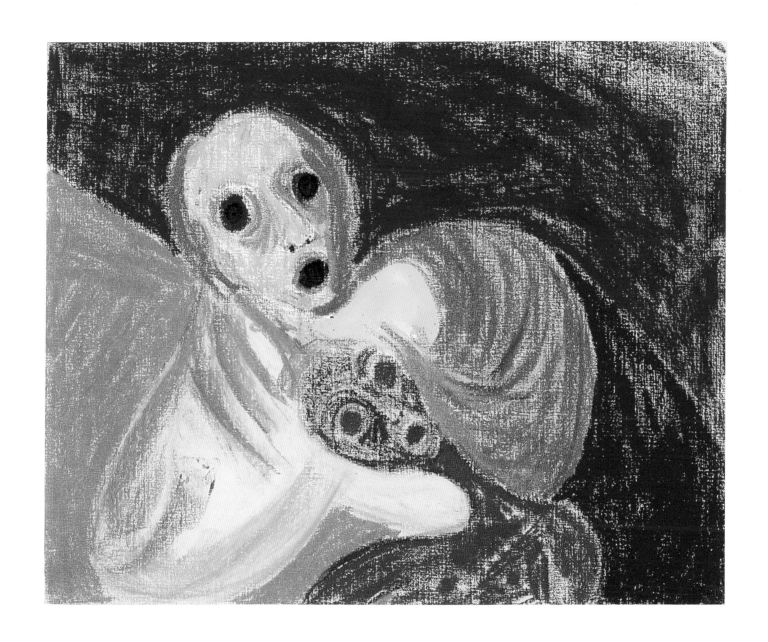

51 IN MEMORY OF MY PARENTS, n.d. · Crayon on paper · 16 x 20 in. (40.6 x 50.8 cm)

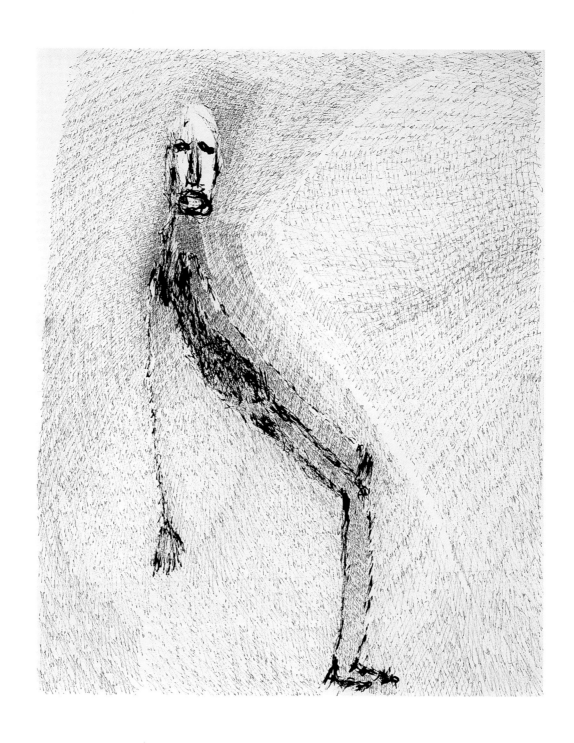

52 UNTITLED (5/6/88), 1988 · Ink on paper · 17 x 13¾ in. (43.2 x 34.9 cm)

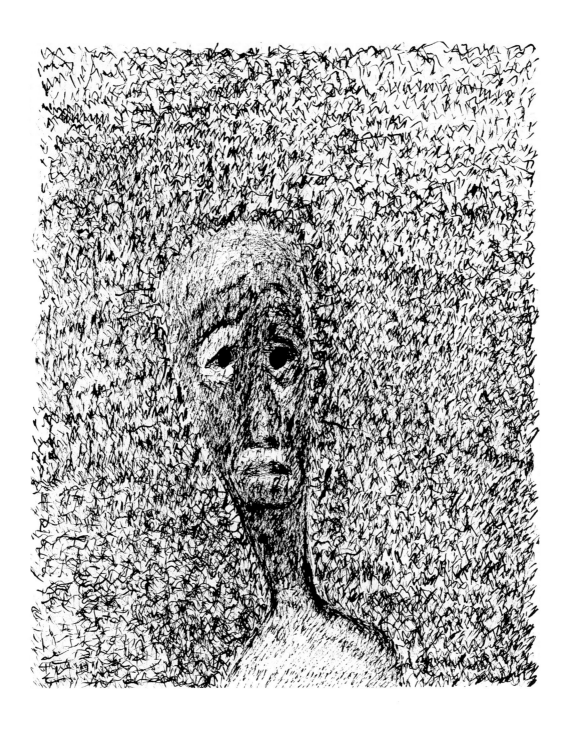

53 UNTITLED (5/23/87), 1987 · Ink on paper · 17 x 13¾ in. (43.2 x 34.9 cm)

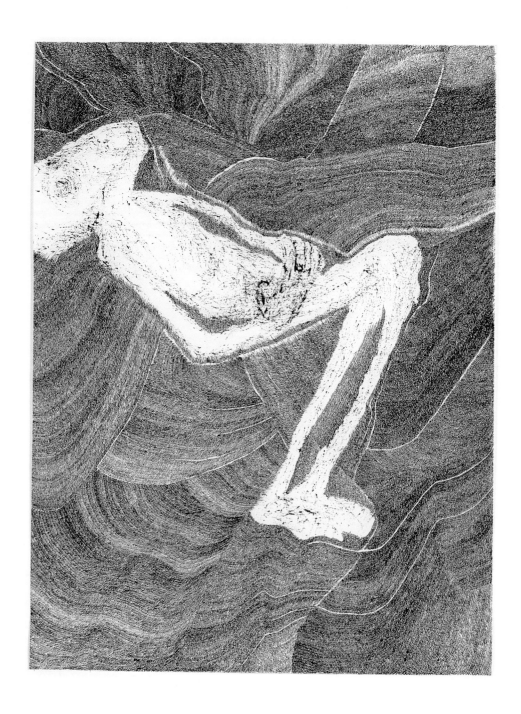

54 UNTITLED (11/16/89), 1989 · Ink on paper · 14 x 10½ in. (35.6 x 26.7 cm)

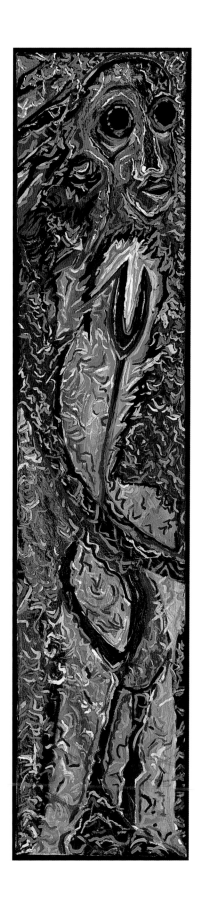

55 UNTITLED, 1989 · Oil on canvas · 69 x 15 in. (175.3 x 38.1 cm)

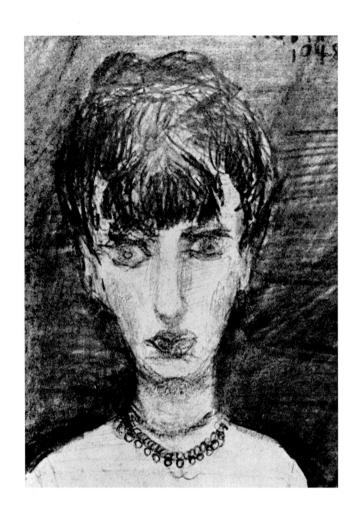

HALINA KORN (1902–78)

HALINA KORN (née Halina Julia Korngold) was born in Warsaw. Her parents, three brothers, and sister were killed, along with her extended family, during the German occupation of Poland in World War II. Korn was in France at the time and eventually made her way to Britain, where she married a Polish artist, Marek Zulawski, in 1948. She lived in London for rest of her life. That city figures prominently in her paintings, which are marked by a simplicity of imagery conveyed through broad areas of intense color. In addition to her paintings, Korn wrote and illustrated an autobiography of her childhood that was published in Poland.

SELF-PORTRAIT, 1948 · Pencil drawing · 7½ x 5½ in. (19.1 x 14.0 cm)

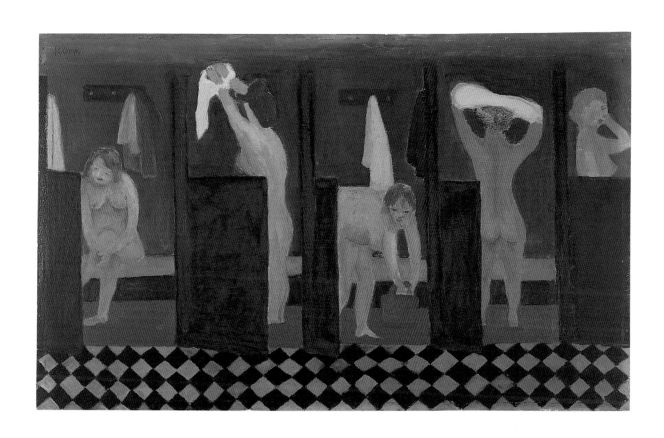

56 BATHHOUSE, n.d. · Oil on board · 15 x 24 in. (38.1 x 61.0 cm)

MÅNA LAGERHOLM (B. 1946)

MÅNA LAGERHOLM was born on the southeast coast of Sweden and spent her childhood there before traveling to England in 1968 to study painting. After earning a degree at Falmouth College of Art in Brighton, she moved back to Sweden, where she lives and works in an artists' commune along the northern coast.

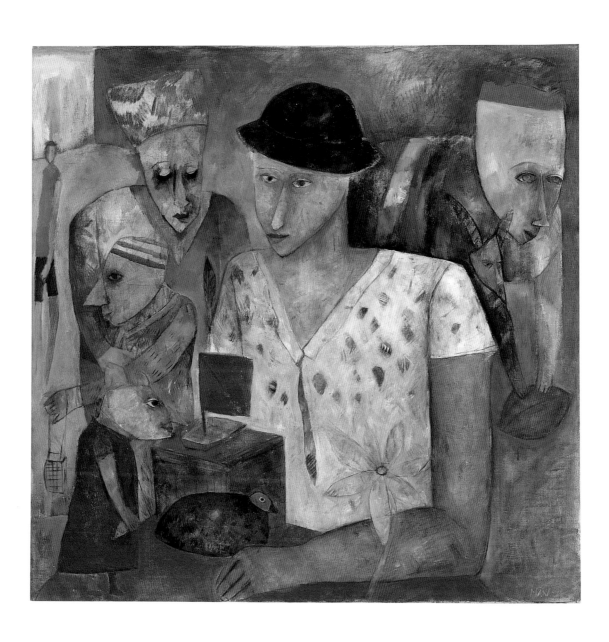

57 MEMORY, 1990 · Acrylic on canvas · 36 x 35 in. (91.4 x 88.9 cm)

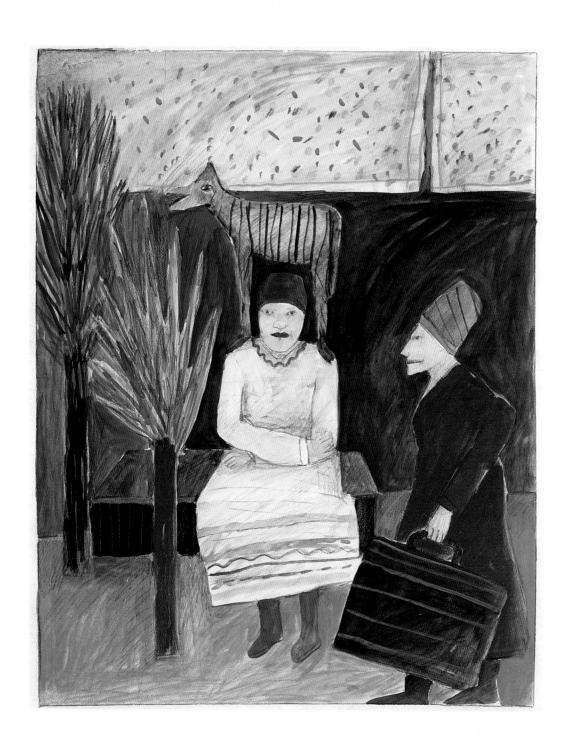

58 SHOPPING SPREE, 1980 · Gouache and crayon on paper · 19½ x 16 in. (49.5 x 40.6 cm)

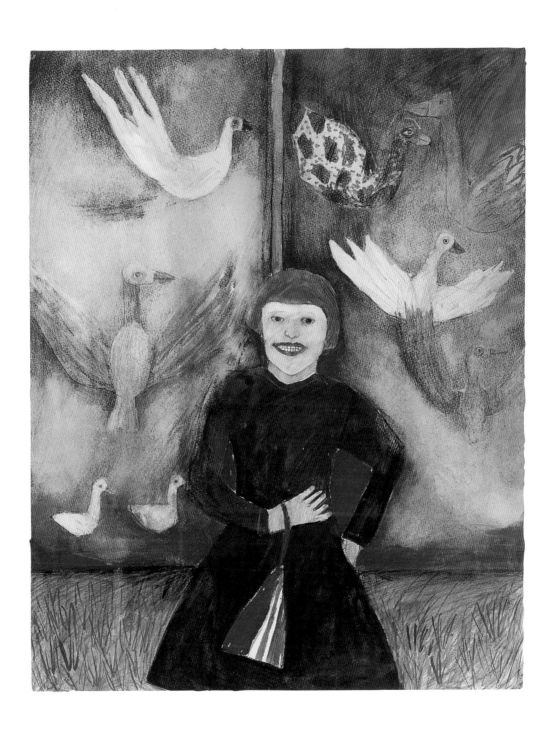

59 THE BIRDS, 1980 · Gouache and crayon on paper · 18¼ x 14½ in. (46.4 x 36.8 cm)

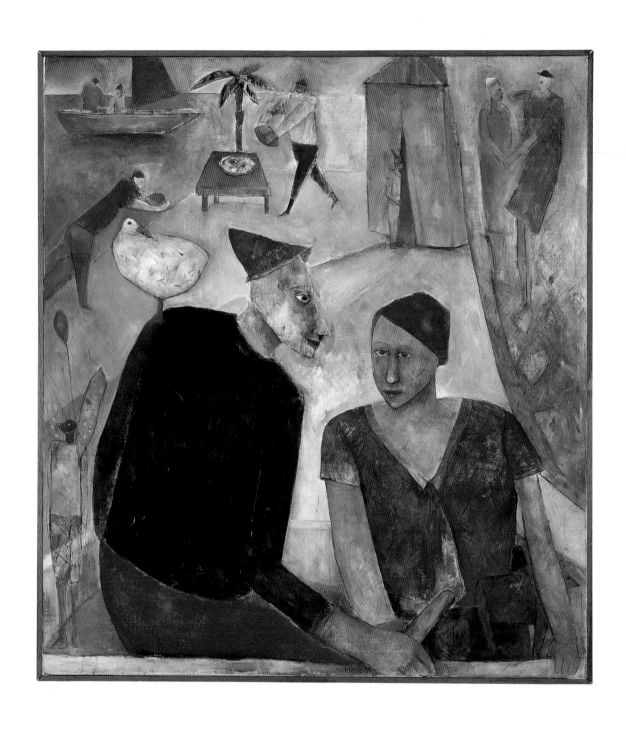

60 ORANGE TENT, 1989 · Acrylic on canvas · 39 x 35½ in. (99.1 x 90.2 cm)

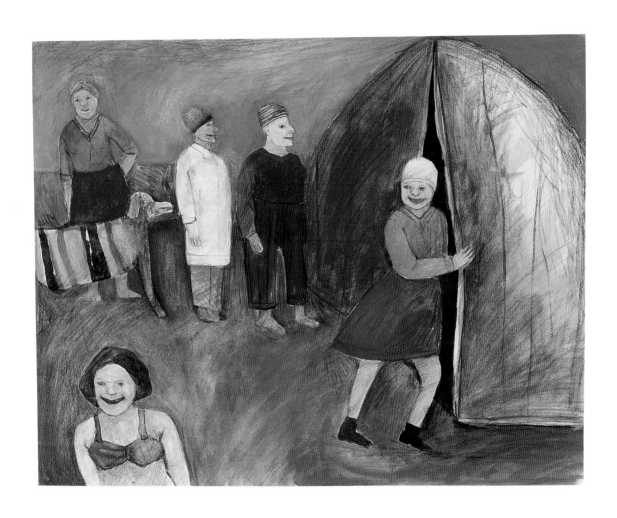

61 RED TENT, 1980 · Gouache and crayon on paper · 14 x 18 in. (35.6 x 45.7 cm)

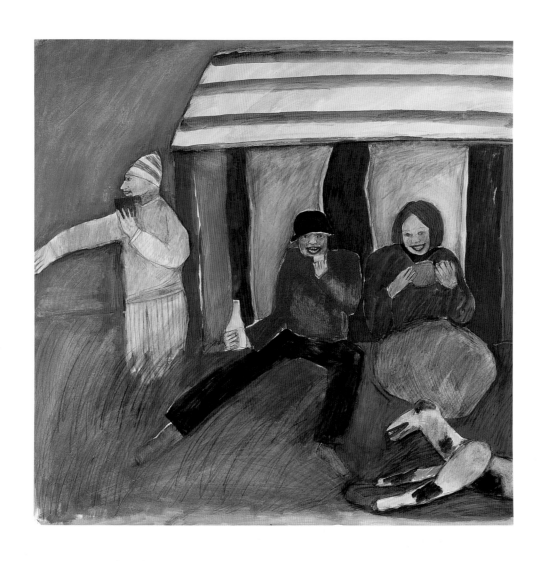

SYLVIA LEVINE (1911–98)

SYLVIA LEVINE began painting in 1956, when she took an art class at the West of England School of Art. She painted with brushes until an employee at a local art supply store showed her a flexible palette knife, which she quickly adopted as her tool of choice. Her paintings are distinguished by their rough surfaces and include wildflowers, landscapes, seascapes, and nudes. Unlike many of the artists included in the book, Levine was well aware of the professional art world and frequented galleries and museums in London. Her work has been exhibited since 1977 at the Royal Academy in London.

63 NUDE (SEATED AT MIRROR), 1986 · Oil on board · 22 x 13¾ in. (55.9 x 34.9 cm.)

I REMEMBER Sylvia Levine telling me how she had gotten started using a flexible palette knife to paint. She had walked to the center of Bristol to pay her first visit to an art shop, and the assistant who helped her, having seen many wannabe artists, declared that if Sylvia wished to paint in oils she would need "one of these." Sylvia added the knife to her assembled tubes of paint and brushes and walked home, precious bundle in hand.

The next day was a Sunday and Sylvia decided to paint. Since she hadn't purchased any canvas, she had to improvise. Like many self-taught artists, she used what was available, in this case cardboard torn from a box. And instead of using her brushes, she began painting with her soon-to-be-treasured palette knife.

The knife stayed with Sylvia for the rest of her life. With it she produced paintings that were accepted on ten occasions by the prestigious Royal Academy in London, making her work much sought-after by serious collectors. Long live the palette knife and Sylvia's memory!
—ALEX GERRARD, art dealer

65 CORNISH LANDSCAPE WITH DONKEYS, 1987 · Oil on board · 13½ x 14¾ in. (34.3 x 37.5 cm)

66 DRIED FLOWERS, n.d. · Oil on board · 18 x 12⅝ in. (45.7 x 32.1 cm)

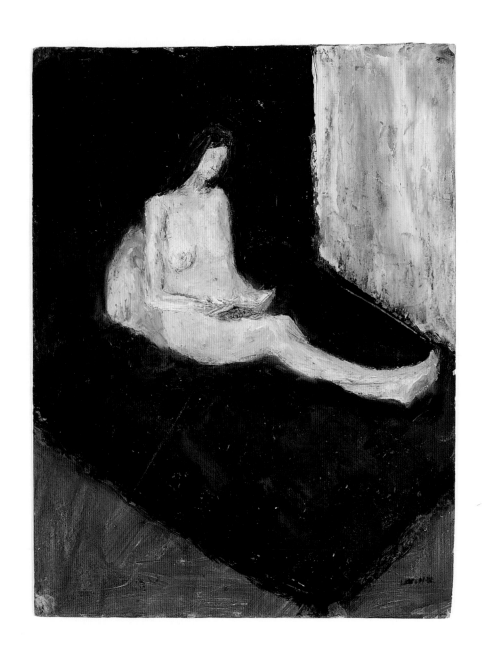

67 NUDE READING, 1980 · Oil on board · 16¼ x 12¼ in. (41.3 x 31.1 cm)

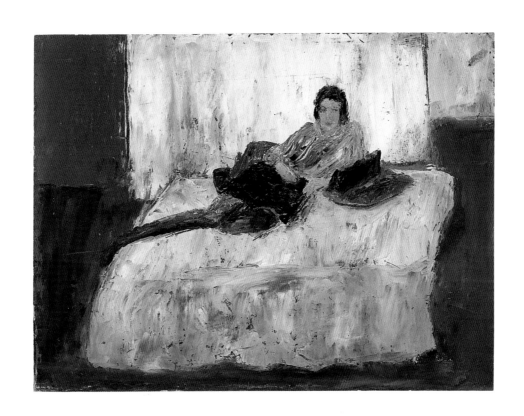

68 GERTRUDE, n.d. · Oil on board · 11⅝ × 15⅜ in. (29.5 × 39.0 cm)

JAMES LLOYD (1905–74)

BORN INTO a farming family in Cheshire, England, James Lloyd became interested in art as a young boy when he made some black-and-white drawings. He served with distinction in the British Army Regiment during World War II and later, while in his forties, married a young woman named Nancy. Together they had nine children, eight of whom survived. Lloyd supported his family as a farm laborer and factory worker, devoting his nights to his art. His pointillist painting style developed from his desire to copy reproductions of works by great English artists such as Constable and Turner. While carefully studying color illustrations of these works in various books and journals, he discovered that the reproductions consisted of thousands of tiny dots, and he set about painstakingly copying this photographic process, dot by dot, using old paintbrushes with just a few hairs each. His subject matter was wide-ranging and included farm animals, local events, and erotic scenes; to amuse his children he also painted pop singers and film stars.

A REMARKABLE man of great warmth, James Lloyd had an acute sense of observation. Before he became famous as a painter, he earned his living at a variety of jobs, such as a builder's laborer, a lamp lighter, a stoker, a bus conductor, a policeman, and, lastly, a farm laborer. He also distinguished himself during World War II as a member of the Coldstream Guards.

Lloyd once remarked that he found it difficult to paint unless his wife and children were all at home around him making noise. He was obsessive about his paintings, spending many hours on each one. In the mid-1960s his reputation and fame spread, and his paintings were featured in many important collections.

Lloyd was always busy painting and looking after his many offspring. When he died of a heart attack at the age of sixty-nine he was greatly missed by his wife and children as well as by all who had had the privilege of coming into contact with him.

—LIONEL LEVY, art gallery director

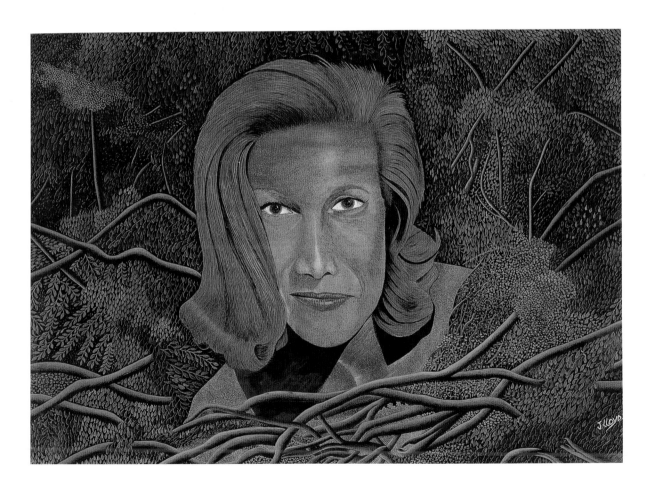

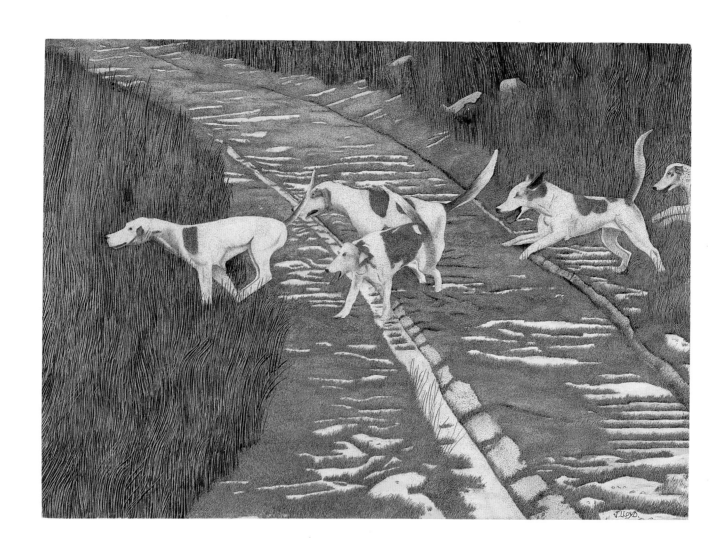

70 FULL BAY, n.d. · Gouache on paper · 16 x 20 in. (40.6 x 51.0 cm)

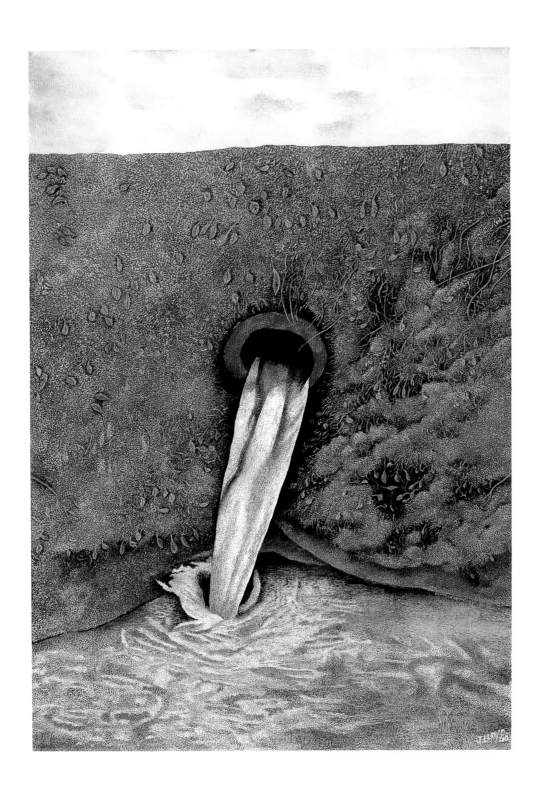

71 SLUICE, n.d. • Gouache on paper • 20 x 14 in. (51.0 x 35.6 cm)

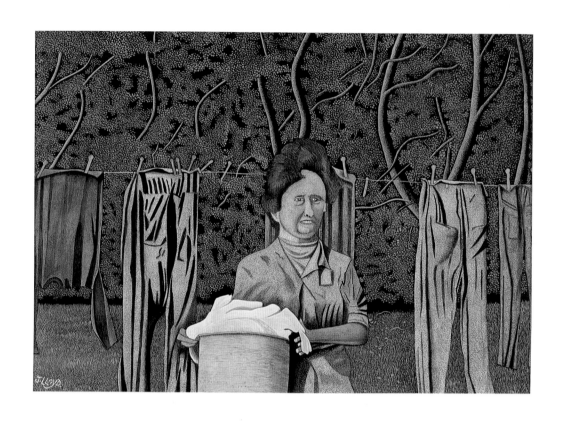

72 WASH DAY, n.d. · Gouache on paper · 10 x 14 in. (25.4 x 35.6 cm)

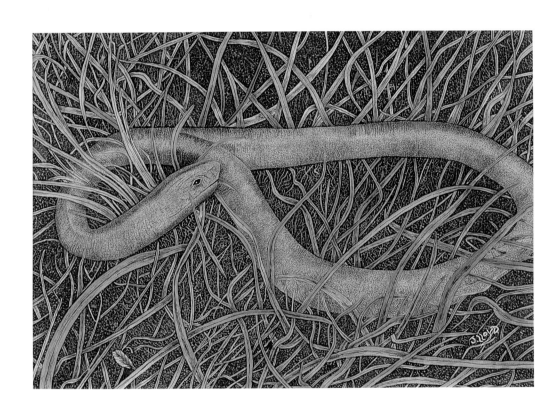

73 SNAKE, n.d. • Gouache on paper • 9^{13}/$_{16}$ x 14 in. (24.9 x 35.6 cm)

107

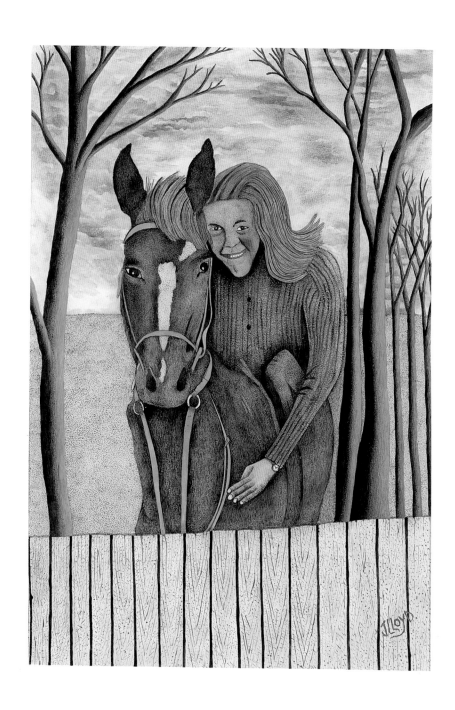

74 GIRL WITH HORSE, n.d. • Gouache on paper • 15 x 10 in. (38.1 x 25.4 cm)

75 BOY WITH LAMBS, n.d. · Gouache on paper · 20½ x 14 in. (52.1 x 35.6 cm)

ALBERT LOUDEN (B. 1943)

ALBERT LOUDEN was born in Liverpool, England, and moved to London with his family at the end of World War II. After finishing school at the age of fifteen, he worked at a series of jobs until finding steady employment as a truck driver. Drawing was a hobby for Louden, something he had excelled in at school but did not pursue further until he decided to change the direction of his life. In 1966, after having devoted his attention mostly to detailed landscapes, he began to look at the world in a more abstract manner, seeing overall shapes rather than minute details. He expanded his iconography to include figures, which have become his standard motif, and experimented with abstraction, defining his figures through broad areas of color and heavy outlines. In 1979, after hearing about the outsider art exhibition organized by Victor Musgrave, Louden wrote to Musgrave to introduce himself and his work. The two met and Musgrave became a mentor and friend. Louden currently lives in London's East End and supports himself entirely through the sale of his art.

76 UNTITLED, n.d. · Pastel on paper · 52½ x 41 (133.4 x 104.1 cm)

77 UNTITLED, n.d. · Pastel on board · 15 x 20 in. (38.1 x 50.8 cm)

78 UNTITLED, n.d. · Pastel on paper · 52½ x 41 in. (133.4 x 104.1 cm)

79 UNTITLED, 1988 · Pastel and watercolor on paper · 19¾ x 15¾ in. (50.2 x 40.0 cm)

80 UNTITLED, n.d. · Pastel on paper · 27⅛ x 31½ in. (68.9 x 80 cm)

81 UNTITLED, 1987 · Pastel on paper · 22½ x 29⅞ in. (57.2 x 75.9 cm)

DWIGHT MACKINTOSH (1906–99)

BORN IN Hayward, California, Dwight Mackintosh lived with his parents and one brother until the age of sixteen, when he was institutionalized for mental retardation. He spent the next fifty-six years in state hospitals, gaining his release in 1978 as part of a national trend toward deinstitutionalizing the mentally handicapped and moving them into group homes. Due to an earlier interest he had shown in art, Mackintosh began attending a day program for artistically inclined disabled adults at the Creative Growth Art Center in Oakland. He flourished in the art studio and remained a participant in the program for twenty years. His drawings were rendered using primarily felt-tip pen, pencil, chalk, and watercolor, and throughout his artistic career his subject matter seldom varied from figures, vehicles, and buildings. Many of his drawings feature indecipherable calligraphic texts.

82 UNTITLED, 1987 · Prismacolor on paper · 20 x 26 in. (50.8 x 66.0 cm)

83 UNTITLED, n.d. • Pastel and ink on paper • 22 × 32 in. (55.9 × 81.3 cm)

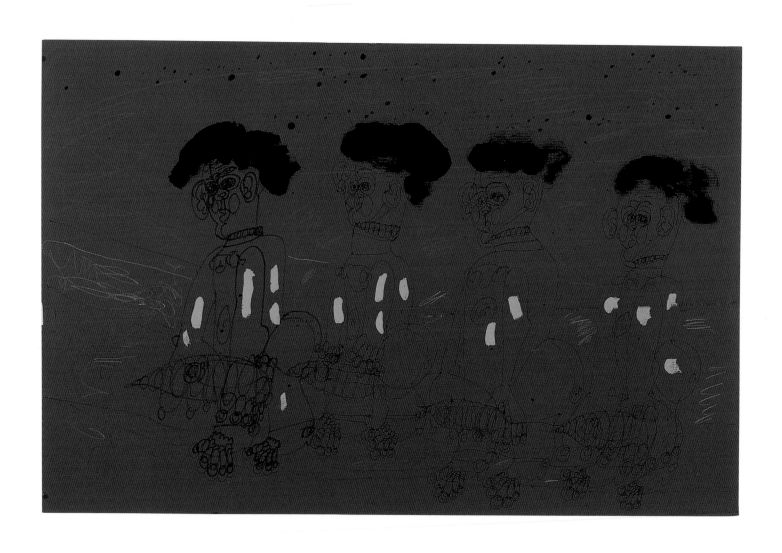

84 UNTITLED, 1984 · Ink and tempera on paper · 22 x 40 in. (55.9 x 101.6 cm)

JAHAN MAKA (1900–1987)

JAHAN MAKA was born in Lithuania and grew up on his family's farm. When he emigrated to Canada in 1927 he changed his name to John Thomason, though his paintings are signed with his birth name. His first years in his new country were spent as an itinerant laborer. He eventually settled in Sherridan, Manitoba, where he worked as a miner. In 1942 he moved to Flin Flon, and for the next twenty-three years he worked for the Hudson Bay Mining and Smelting Co. Encouraged by his godson, Tony Allison, an art student at the University of Manitoba, Maka began to paint in 1968. Allison supplied him with materials and introduced gallery owners and museum curators to his work. Maka painted in a direct style, unconcerned with natural color or perspective; his later works were done on brown and black paper using chalk, crayons, and paint. His work has been exhibited throughout Canada, and he has become a symbol of Canadian self-taught art.

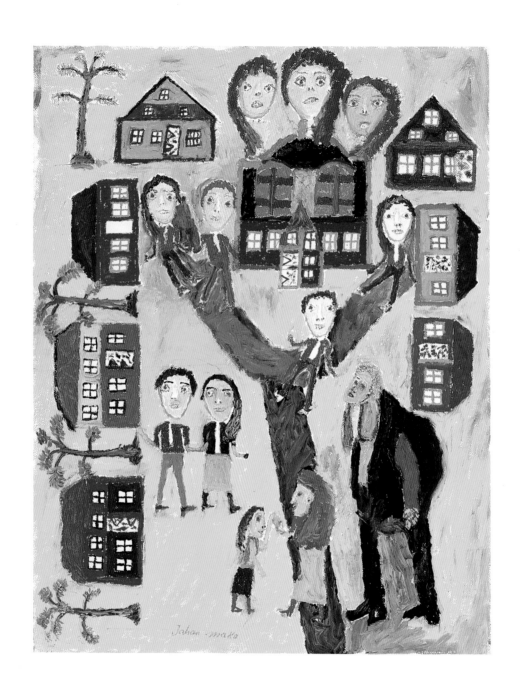

85 THE OLD SCHOOLHOUSE, ca. 1980 · Oil on canvas board · 18 x 14 in. (45.7 x 35.6 cm)

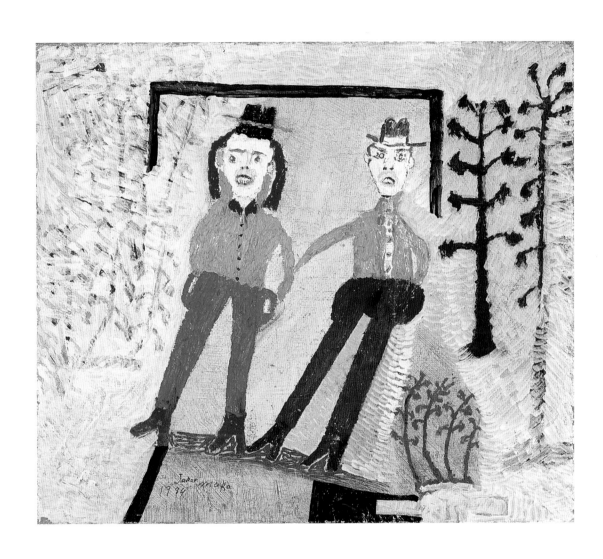

86 THE PRINCE EMIGRATES, 1984 · Oil on canvas · 14½ x 16½ in. (36.8 x 41.9 cm)

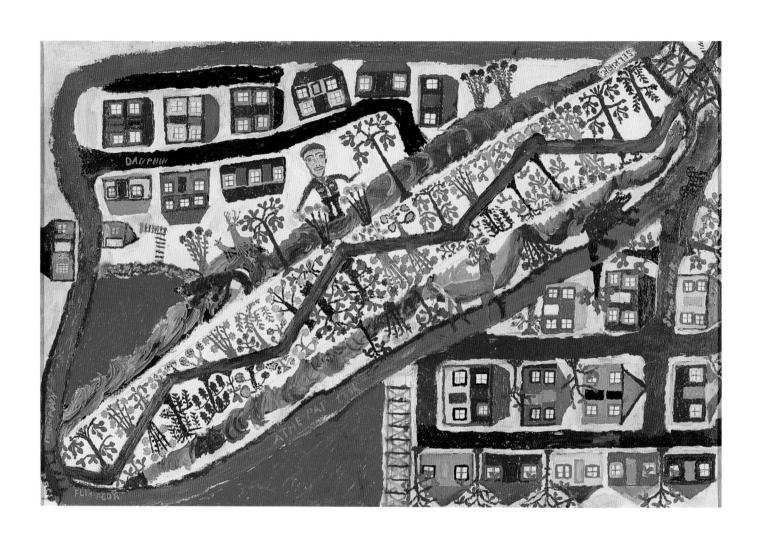

87 MAP OF MANITOBA, ca. 1980 · Oil and pencil on canvas board · 24 x 36 in. (61.0 x 91.4 cm)

JUSTIN McCARTHY (1892–1977)

JUSTIN McCARTHY, the son of a wealthy newspaper executive in Weatherly, Pennsylvania, studied law at the University of Pennsylvania but failed the bar exam. In 1915 he suffered a nervous breakdown and was confined to a state hospital for five years. Inspired by a childhood visit to the Louvre, McCarthy began painting as a hobby. In 1960 he entered some of his paintings in an art show in Stroudsburg, Pennsylvania, where he was discovered by the artists and collectors Dorothy and Sterling Strauser. McCarthy's subject matter ranges from landscapes to movie stars, reflecting his familiarity with popular culture. The nervous application of the various media with which he worked gives his art a forceful sense of motion.

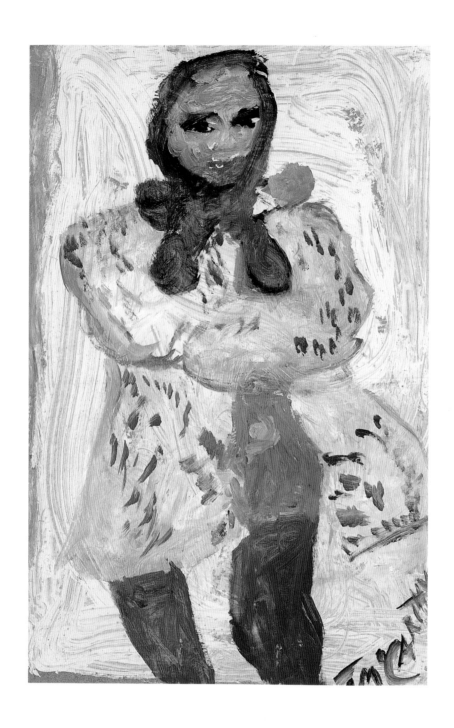

88 MARILYN, 1965 · Oil on board · 24 x 16 in. (61.0 x 40.6 cm)

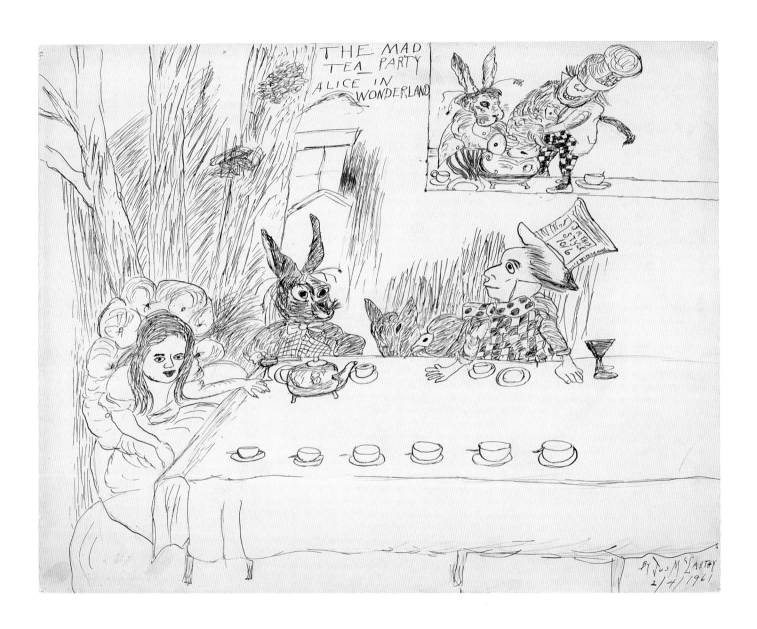

89 THE MAD TEA PARTY, 1961 · Pen and ink on paper · 22 x 28½ in. (55.9 x 72.4 cm)

JUSTIN MCCARTHY had been painting for more than forty years when he was discovered at a local outdoor art show in Stroudsburg, Pennsylvania, by the watercolor artist Dorothy Strauser. Dorothy's first thought when she spotted his work was, "If I had seen these in a museum I would have thought they were great." Her husband, Sterling, also a painter and collector, agreed, and the following year they acquired their first McCarthy painting by offering the artist the exact amount of money he needed to fix his car. The Strausers collected and promoted McCarthy's work and remained his close friends until his death in 1977.

McCarthy often brought vegetables to staff members at various museums in appreciation for exhibiting his work. At a comprehensive solo exhibition held at the Pennsylvania Academy of the Fine Arts, he was asked to speak following opening remarks and an eloquent presentation by another exhibiting artist, the woodcarver Elijah Pierce. McCarthy rose, quietly said, "Thank you very much for inviting me," and then sat down.

—LEE KOGAN, director of the Folk Art Institute, New York

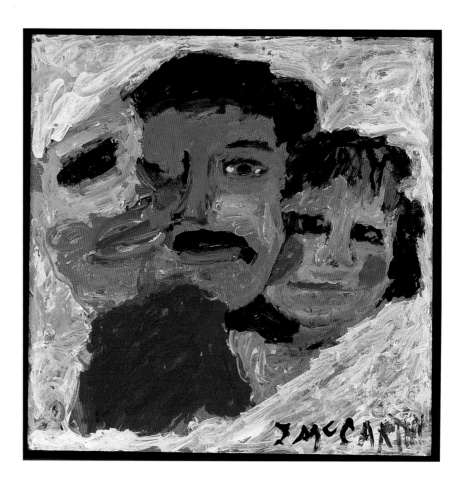

90 THREE'S A CROWD, 1960 · Oil on board · 12 x 12 in. (30.5 x 30.5 cm)

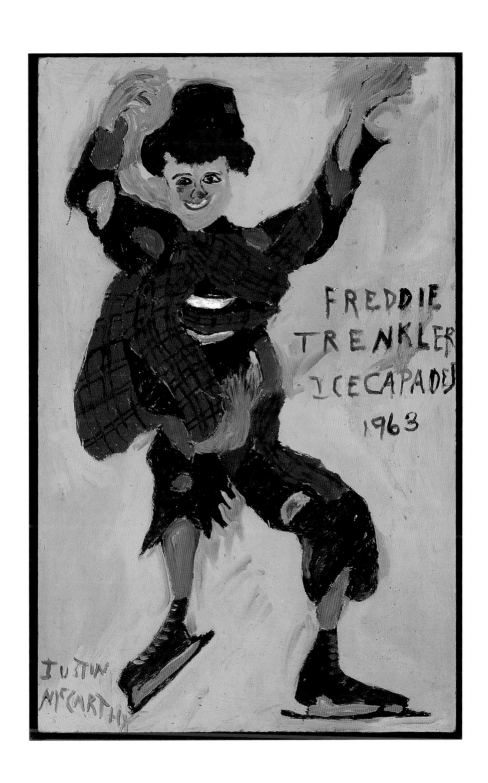

91 FREDDIE TRENKLER, 1963 · Oil on board · 22 x 14 in. (55.9 x 35.6 cm)

MICHEL NEDJAR (B. 1947)

MICHEL NEDJAR was born in Soisy, France, near Montmorency. With the exception of occasional drawing classes, he professed a dislike for school and left at the age of fourteen to begin an apprenticeship under a master tailor in Les Halles. Four years later, in 1965, he earned a fashion diploma. Nedjar contracted tuberculosis in 1968 while serving in the military and spent eighteen months in a sanatorium. After his recovery he traveled extensively for a number of years, first to North Africa and Europe and then to India and Mexico. He returned to Paris in 1976 and began making dolls, inspired by the "magic dolls" he had seen in Mexico; in 1980 he began drawing, using found materials. Nedjar cofounded L'Aracine, France's museum of *art brut,* in 1982. In addition to his later drawings, which feature simplified human faces and indistinct figures, he is an accomplished avant-garde filmmaker.

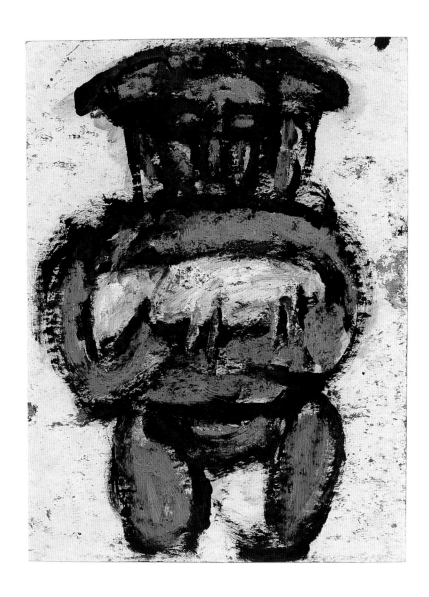

92 UNTITLED, 1991 · Acrylic over charcoal on paper · 12 x 9 in. (30.5 x 22.9 cm)

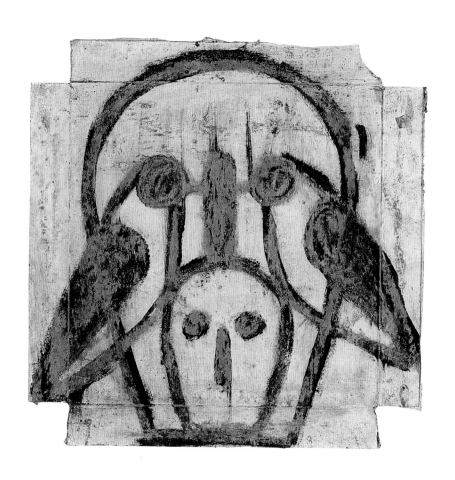

93 UNTITLED, n.d. · Acrylic on cardboard · 11½ x 11½ in. (29.2 x 29.2 cm)

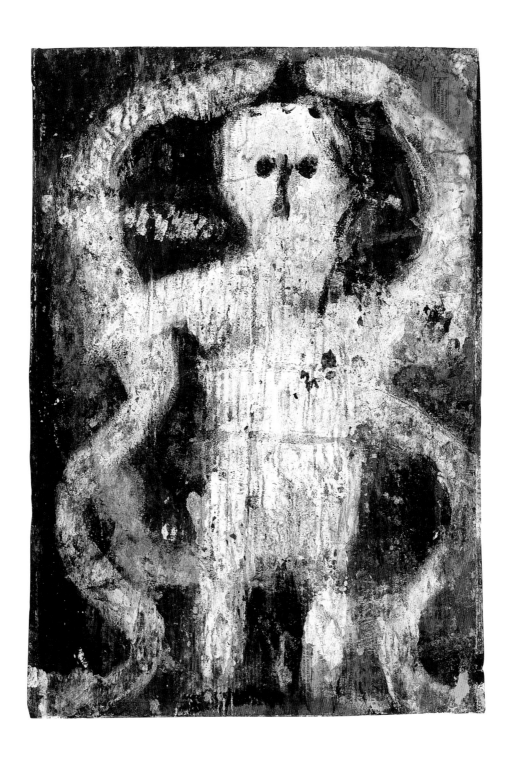

94 UNTITLED, n.d. · Acrylic on layered newspaper · 18 x 12½ in. (45.7 x 31.8 cm)

NIKIFOR (1895–1968)

NIKIFOR was born in the region of Podkarpacie, Poland, to a domestic servant and an unknown father. Illiterate and suffering from a severe speech impediment, he was forced to provide for himself as a beggar following his mother's death. He began painting after being given a set of watercolors by a doctor during a hospital stay, and throughout his life he traveled from village to village selling his art. He marked his work with a round seal that identified him as "Nikifor-Matejko" (the last name borrowed from a famous Polish artist), thus indicating his desire to be considered a professional artist. Nikifor painted cityscapes and architectural renderings based on his various travels, as well as religious images. His forms are simple and his compositions are busy with color. By the time he received recognition for his art, the creative process was more of a burden than a means of expression.

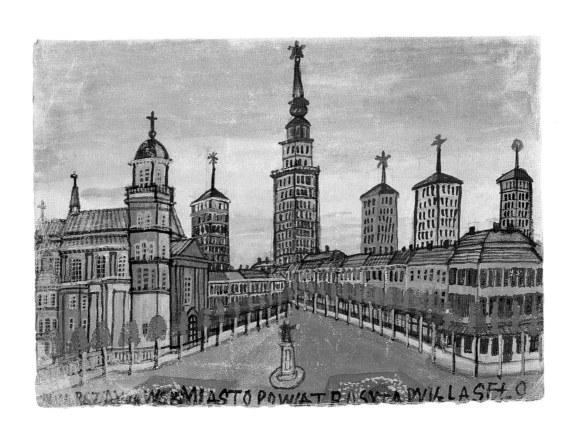

95 WARSAW, ca. 1950 · Watercolor on paper · 11¼ x 15 in. (28.6 x 38.1 cm)

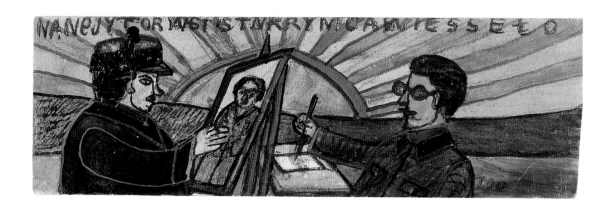

96 SELF-PORTRAIT, ca. 1935 · Watercolor on paper · 4 x 12 in. (10.2 x 30.5 cm)

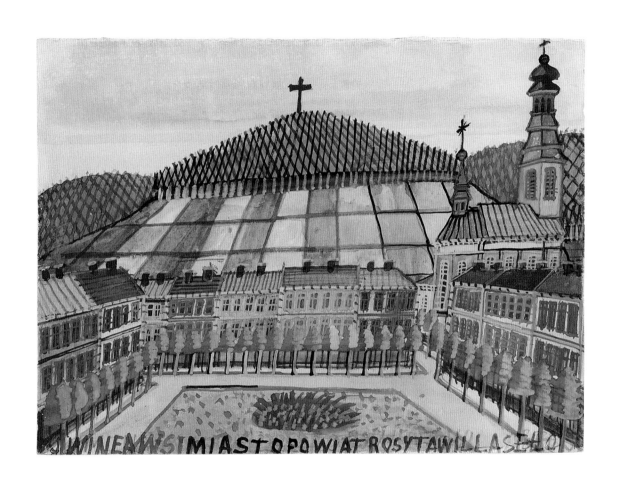

97 ROSYTAWILLA, ca. 1955–60 · Watercolor on paper · 9½ x 13 in. (24.1 x 33.0 cm)

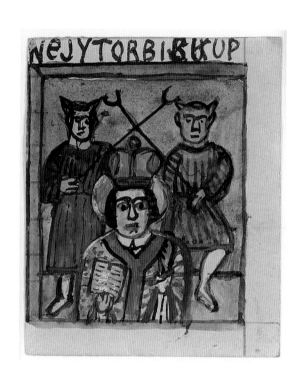

98 BISHOP AND DEVILS, ca. 1935 · Watercolor on paper · 4¾ x 4 in. (12.1 x 10.2 cm)

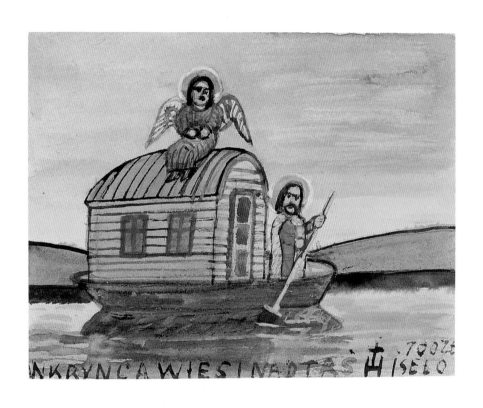

99 NOAH'S ARK, ca. 1935 · Watercolor on paper · 6½ x 8½ in. (16.5 x 21.6 cm)

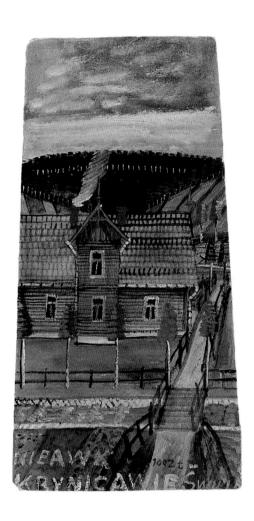

100 KRYNICA SPRING, n.d. · Watercolor on paper · 10½ x 6 in. (26.7 x 15.3 cm)

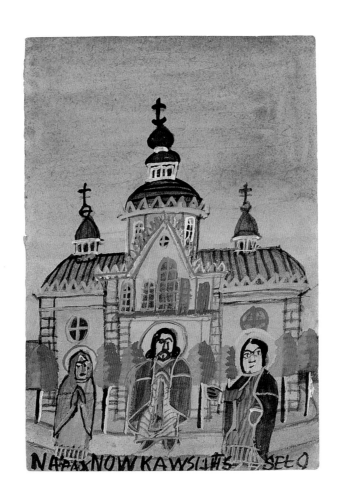

PERIFIMOU (ALEXANDER GEORGIOU) (B. 1916)

ALEXANDER GEORGIOU, who later took his father's nickname, Perifimou (the famous one), was born on Cyprus in a village near the town of Nicosia. In 1935 he moved to Britain, where he worked as a chef and a tailor. He was called into service at the outbreak of World War II and fought for Britain in North Africa, Malta, and Italy. After the war a chronic skin condition forced him into unemployment until 1973, when the British Legion recommended him for the post of gallery guard at the Royal Academy. Eventually he became a guard at the Tate Gallery, at which time he began to draw "out of boredom." Victor Musgrave, founder of the Outsider Archive, noticed him drawing on scraps of paper during a visit to the Tate Gallery and the two became friends. Perifimou retired from the gallery at the age of sixty-five and in 1990 moved to the country with his wife. His images are defined through broad areas of color and consist primarily of humans, animals, and birds. He has willed the bulk of his work to his hometown on Cyprus.

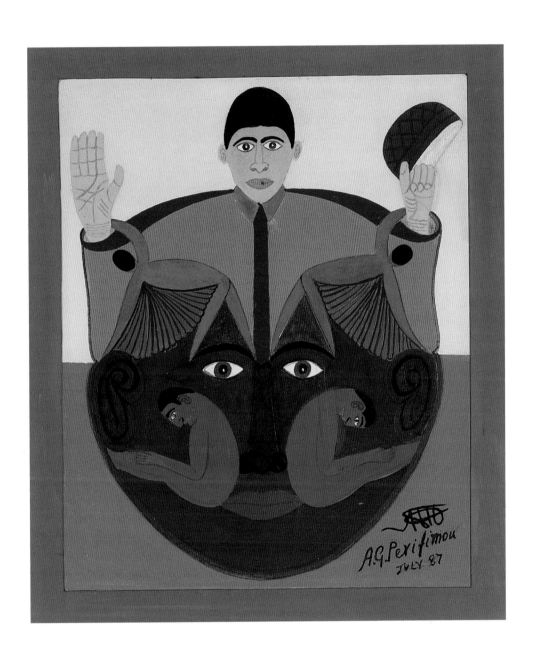

102 EARTHLINGS, 1987 · Acrylic on board · 16 x 13½ in. (40.6 x 34.3 cm) 143

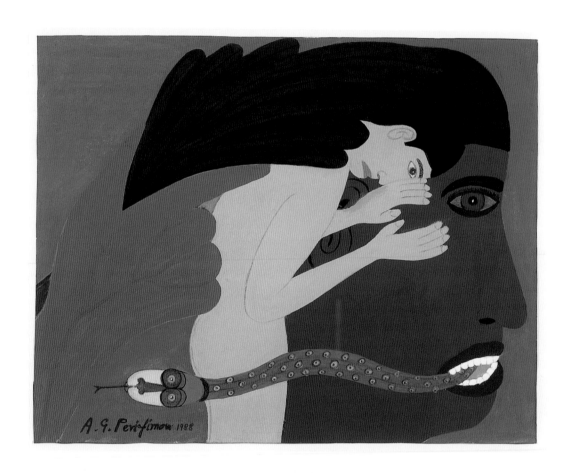

103 PSYCHE, 1988 · Gouache on paper · 10¾ x 13¾ in. (27.3 x 34.9 cm)

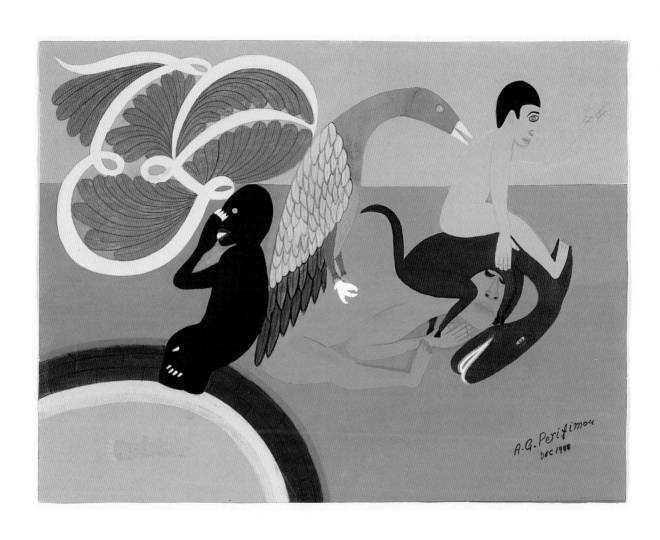

MAX RAFFLER (1902–88)

MAX RAFFLER was born in the Bavarian town of Greifenberg, Germany. His dream of becoming a professional artist was abandoned when he and his two sisters were forced to take over the family farm after the death of their father. As a result, painting was something Raffler learned on his own and in his spare time. One of his patrons was a priest who encouraged him to paint biblical images for display in the village church. Raffler proceeded to illustrate a multitude of scriptural stories, from Genesis to the Crucifixion. He also painted landscapes and scenes of rural life. Unfortunately, much of his work was destroyed by his sisters, with whom he lived until his death.

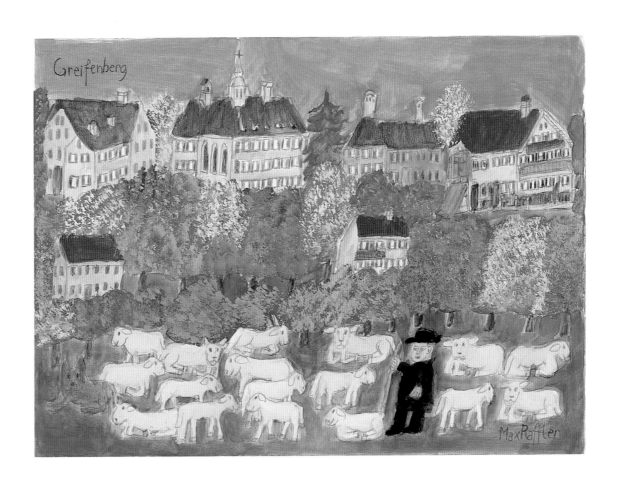

105 GREIFENBERG, ca. 1975 · Watercolor and pencil on paper · 12 x 16 in. (30.5 x 40.6 cm)

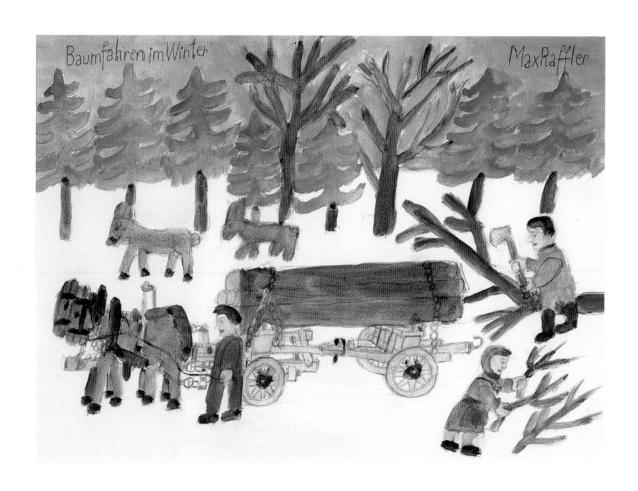

106 WINTER SCENE, ca. 1975 · Watercolor and pencil on paper · 12 x 16 in. (30.5 x 40.6 cm)

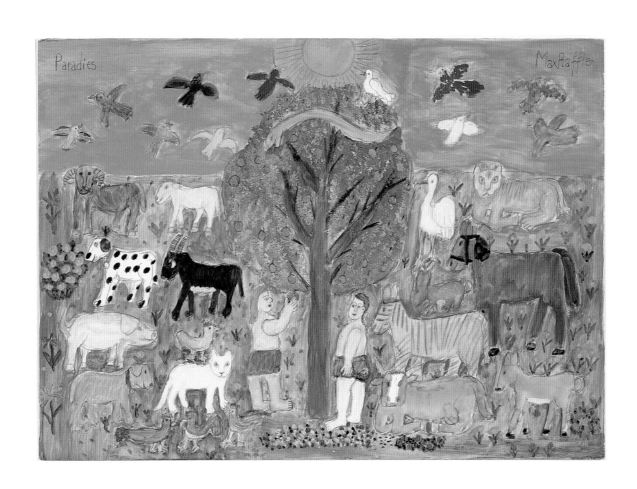

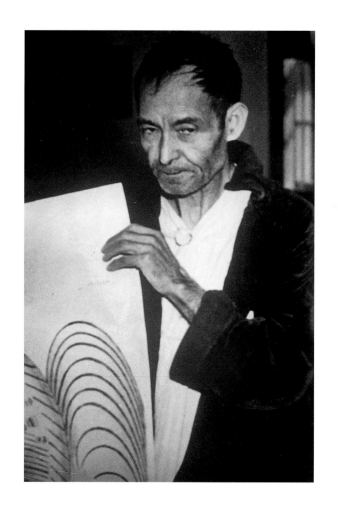

MARTIN RAMIREZ (1885–1960)

BORN IN Jalisco, Mexico, Martin Ramirez worked as a laundryman until he crossed the border in search of a better life. Settling in California sometime between 1900 and 1910, he worked as a section hand on the railroad but eventually found the work too physically demanding. Overwhelmed by his situation, he became an indigent in Los Angeles and in 1930 was placed in an institution by Los Angeles authorities. He was eventually transferred to DeWitt State Mental Hospital in Auburn. In 1950 Ramirez began to draw on scraps of paper he glued together using a variety of substances, including mashed potatoes. In 1954 he showed a few of his works to a visiting psychologist, Dr. Tarmo Pasto, who immediately recognized their artistic merit and encouraged him to continue drawing. Ramirez remained at DeWitt Hospital until his death in 1960. In 1968 Dr. Pasto introduced his work to the Chicago artist Jim Nutt, who was teaching at Sacramento State College. Nutt and a Chicago art dealer, Phyllis Kind, purchased and began to exhibit Ramirez's work, which features such images as cowboys, Madonnas, trains, tunnels, and animals in densely patterned spatial constructions.

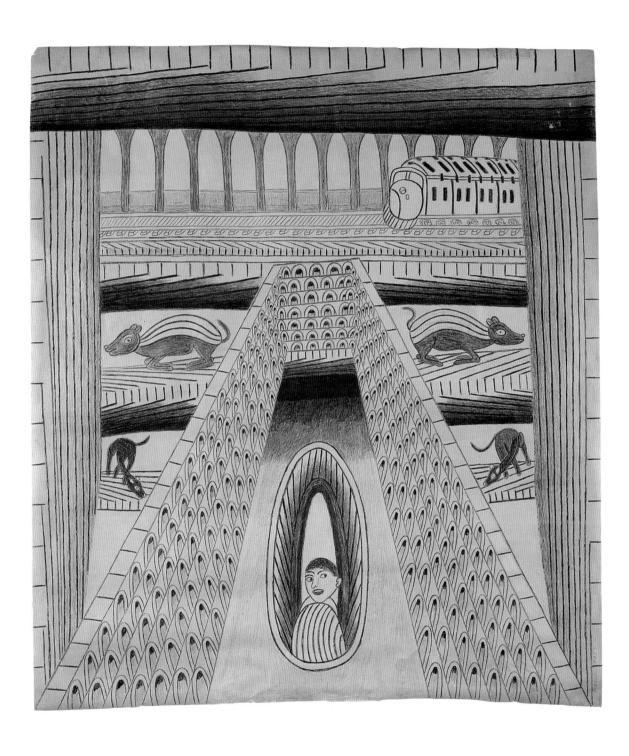

108 COURTYARD, ca. 1953 · Pencil and colored pencil on paper · 40½ x 36 in. (102.9 x 91.4 cm)

FRIEDRICH SCHRÖDER-SONNENSTERN (1892–1982)

FRIEDRICH SCHRÖDER-SONNENSTERN was born in Kuckerneese near Tilsit, Lithuania, and spent his youth in and out of correctional institutions. While working as an itinerant farm laborer in 1910 he was accused of theft and resisted arrest with a knife. He was declared insane and was committed to a mental institution for five months. In 1917 he was again institutionalized after being arrested for smuggling. Upon his release he became quite successful as a fortuneteller and healer, calling himself the "Esteemed Professor Dr. Eliot Gnass von Sonnenstern, Psychologist of the University Sciences." He spent his profits buying food for the hungry. Eventually he was arrested for practicing false medicine and incarcerated, during which he met an artist who inspired him to draw. Later he moved to Berlin and devoted all of his attention to his art. He developed a following and by 1959 was earning a substantial income from his work. His drawings are laden with sexual imagery and executed in a clear, hard-edged style.

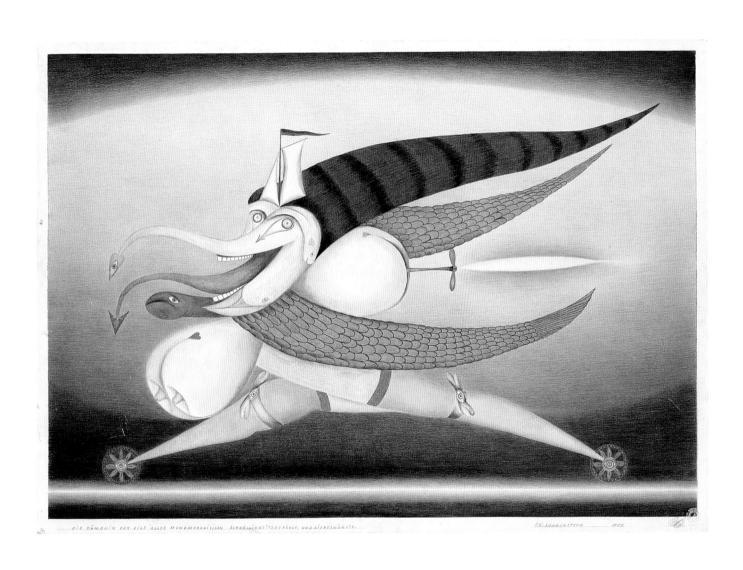

109 THE DEMONESS OF URGENCY, 1958 · Colored chalk on cardboard · 25 x 35 in. (63.5 x 88.9 cm)

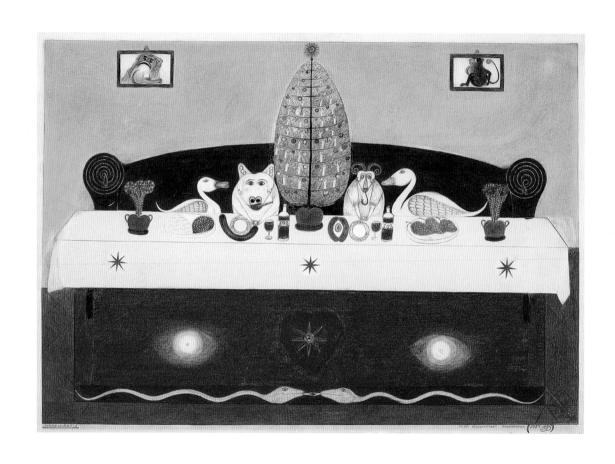

110 *SCHÖNWÄRSIA MONDMÄRCHEN*, 1954 · Colored pencil and crayon on paper · 20 x 28½ in. (50.8 x 72.4 cm)

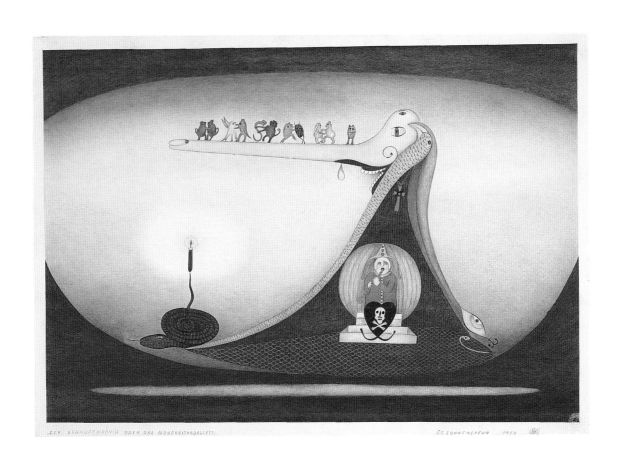

111 THE KING OF SNIFFLES, 1958 · Colored pencil on paper · 20 x 28⅝ in. (50.8 x 72.7 cm)

JON SERL (1894–1993)

BORN IN Olean, New York, into a family of traveling vaudevillians, Jon Serl held many jobs throughout his eccentric life, including singer, dancer, female impersonator, actor, voice-over, and Hollywood screenwriter. He eventually left Hollywood for Laguna Beach, California, and settled in San Juan Capistrano, where he began his artistic career in 1949. The shallow spaces of Serl's paintings are occupied primarily by attenuated figures in rather complex spatial arrangements. His work addresses a number of themes, including the glory of America between the world wars and the differing roles of men and women. Throughout his long career Serl painted well over twelve hundred works.

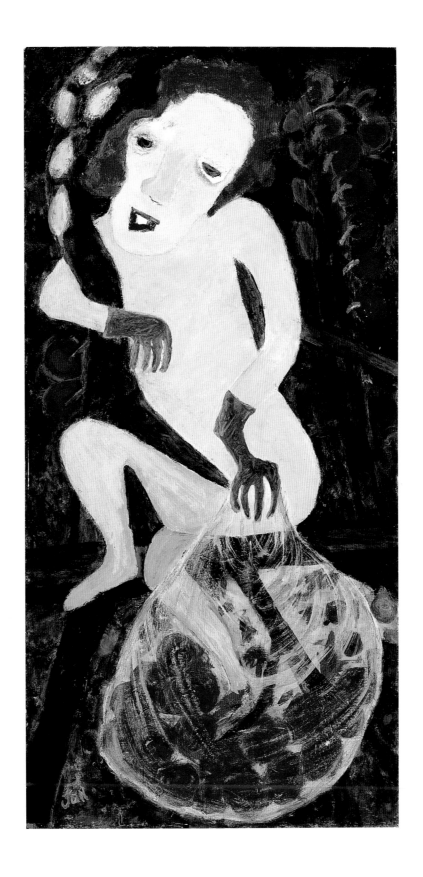

112 UNTITLED, n.d. · Oil on board · 48 x 23 in. (121.9 x 58.4 cm)

IN THE hottest part of a desert summer, the buzz of insects becomes part of the landscape. We sit in the kitchen of ninety-six-year-old Jon Serl and drink in the silence.

"It'll be any minute now," he says.

We spend the morning clashing cultures. His favorite game is to shock me—and he can, because he lives the country life and imagines me to be the eternal city boy.

As the morning wears on he gets tired. His pronouncements become more heartbreaking and gentler. He paints, and as always I observe him in awe and with the deepest respect, for when Jon Serl paints the world begins anew. The studio warms to the high eighties and a glorious beam of sunlight shines on the freshly painted picture. The only sounds come from his Chihuahuas and the resident poultry, the buzzing flies, and the paint-loaded glue brush skritch-skritching on the Masonite. "Don't be afraid of it," he mumbles to himself, "just go on . . . go on."

His eyes suddenly light up. "Here he is. Now he's here." Then he dips a forefinger in a nearby honey pot.

I hear buzzing near the open window. Then I see what he's talking about . . . a large honeybee suddenly appears out of the blinding sun, landing on Serl's honey-tipped finger. The bee stays momentarily while Serl talks to him and then flies back outdoors, leaving the silence and the warm triumph of the old man inside.

—RANDALL MORRIS, art gallery owner

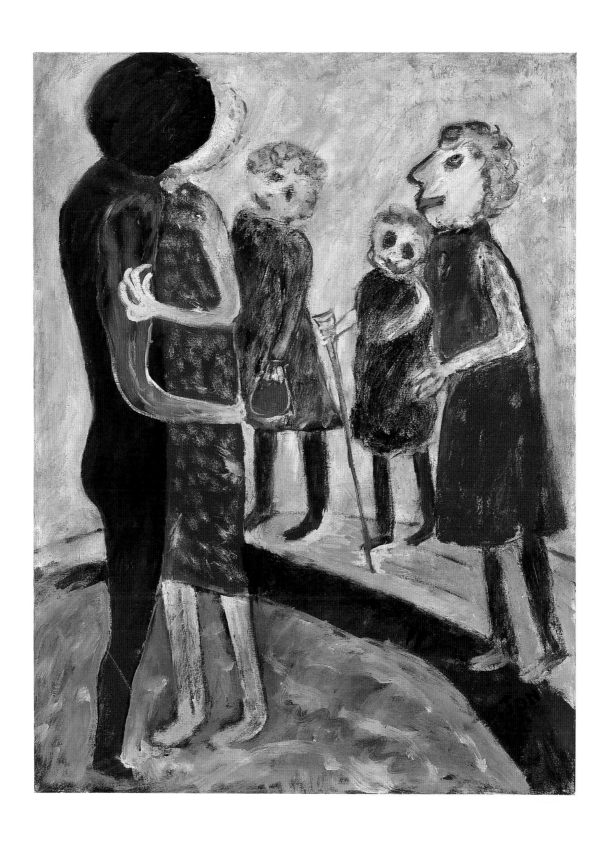

113 A SOLDIER RETURNS, 1982 · Oil on canvas · 40⅛ x 30¼ in. (101.9 x 76.8 cm)

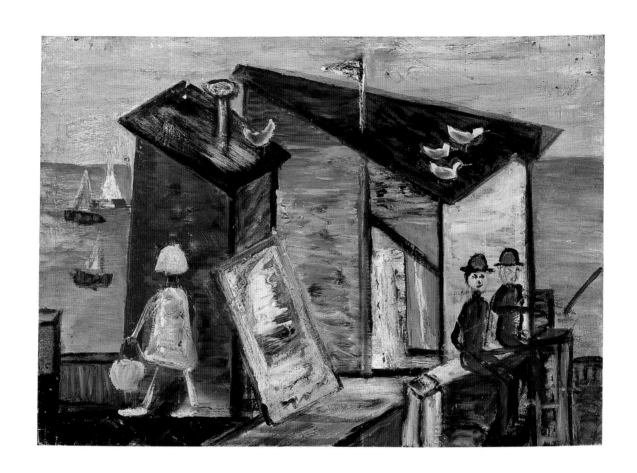

114 PIER, n.d. · Oil on board · 17 x 24 in. (43.2 x 61.0 cm)

115 THE VISITOR, n.d. · Oil on board · 14 x 27½ in. (35.6 x 69.9 cm)

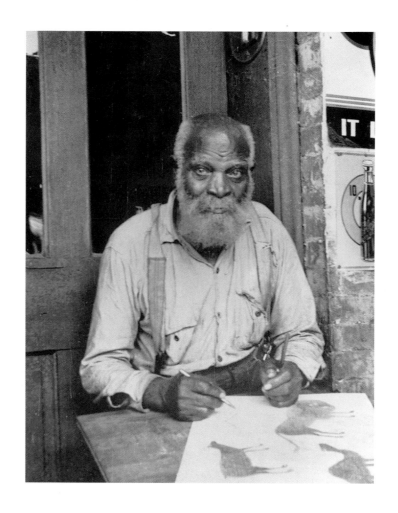

BILL TRAYLOR (1854–1949)

BILL TRAYLOR was born a slave on the George Traylor plantation near Benton, Alabama. He lived there for more than eighty years, working as a farmhand. In the mid-1930s, after the death of his wife and the Traylors, he moved to Montgomery. One day he began to draw while sitting in front of a pool hall on Monroe Street. Using a pencil and a piece of cardboard, he drew simple images from his life on the farm and from his observations of events on the street. A young Montgomery artist, Charles Shannon, noticed Traylor sitting on his box and working intently. Shannon befriended him and visited him regularly, each week bringing him supplies and a few dollars. Traylor's drawing technique was quite deliberate: using a block of wood as a straight edge, he rendered a basic geometric form and built the rest of the image around that initial shape. His compositions gradually became more complex, while his media expanded to include crayons, poster paint, and gouache. He left Monroe Street in 1942 to live with his children, at which point he stopped drawing. He was placed in a nursing home in 1947 and remained there until his death.

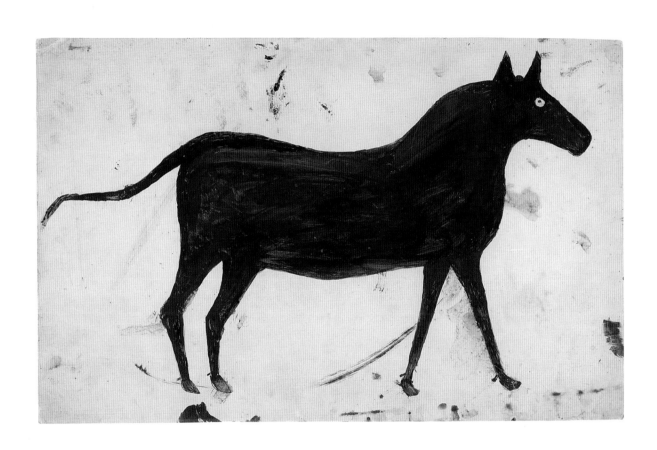

116 BROWN MULE, 1939 · Pencil, crayon, and gouache on paper · 14 x 21½ in. (35.6 x 54.6 cm)

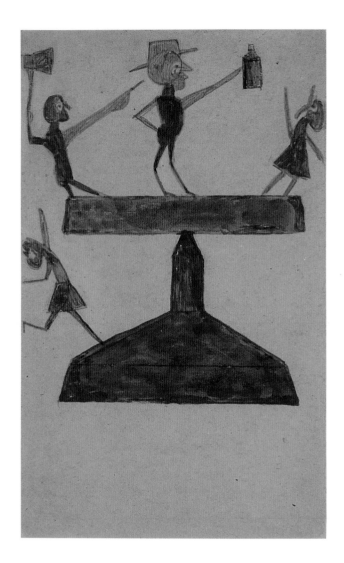

117 WALNETTOS FIGURES CONSTRUCTION, 1939 · Tempera on cardboard · 12⅞ x 7 in. (32.7 x 17.8 cm)

118 FOUR FIGURES CONSTRUCTION, ca. 1939 · Pencil and tempera on cardboard · 13 x 8 in. (33.0 x 20.3 cm)

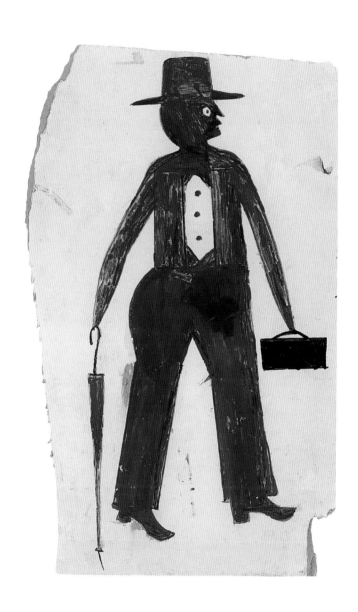

119 BLUE MAN WITH UMBRELLA AND SUITCASE, 1939 · Pencil and tempera on cardboard · 15¼ × 8½ in. (38.7 × 21.6 cm)

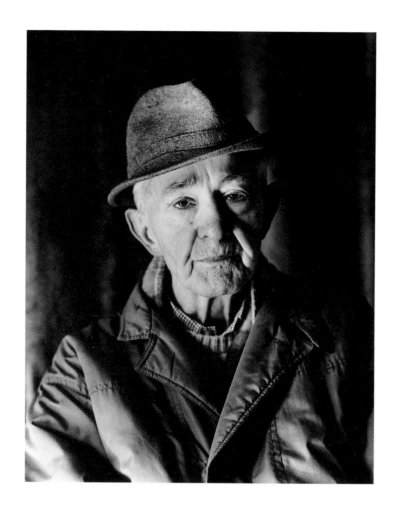

OSWALD TSCHIRTNER (B. 1920)

REARED BY an aunt and uncle in Vienna, Austria, Oswald Tschirtner was deeply religious, attending a seminary school at age ten with the goal of becoming a priest. In 1937 he was conscripted into the German army, fought in the siege on Stalingrad, and spent the remaining years of the war in a prison camp in the south of France. Upon his return to Vienna he displayed a feverish religiosity coupled by fits of violence. In 1947 he was committed to a psychiatric hospital, and in 1954 he was transferred to the Klosterneuburg Hospital (also known as Gugging) near Vienna. Shortly after his arrival Tschirtner reluctantly began drawing with the encouragement of then-director Dr. Leo Navratil. His style is one of extreme reduction, masterfully conveying an image by providing a minimal amount of information. His human figures, for instance, consist only of a head with elongated arms and legs. Tschirtner has lived in the Haus der Künstler (Artists' House), since its opening in 1981.

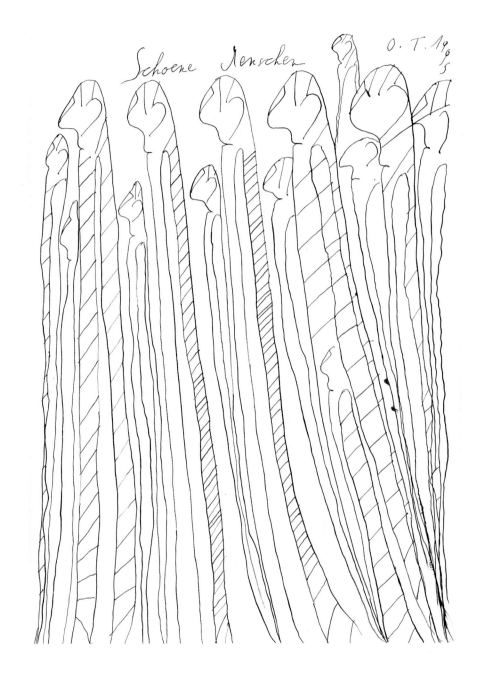

120 BEAUTIFUL PEOPLE, 1995 · Ink on paper · 16½ x 11¾ in. (41.9 x 29.8 cm)

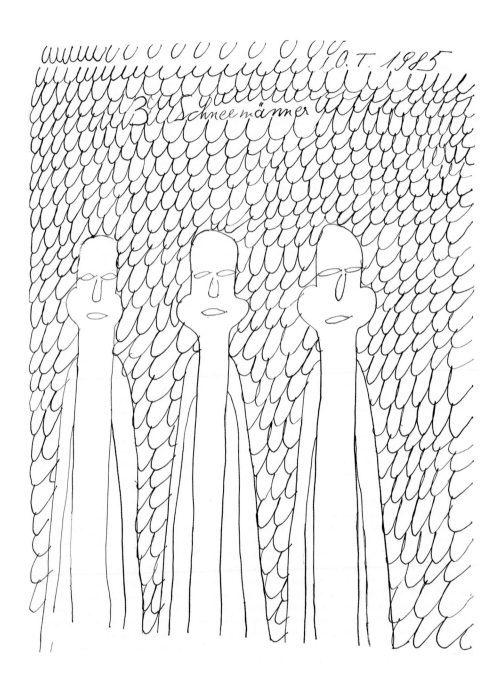

121 SNOWMEN, 1985 · Ink on paper · 16½ x 11¾ in. (41.9 x 29.8 cm)

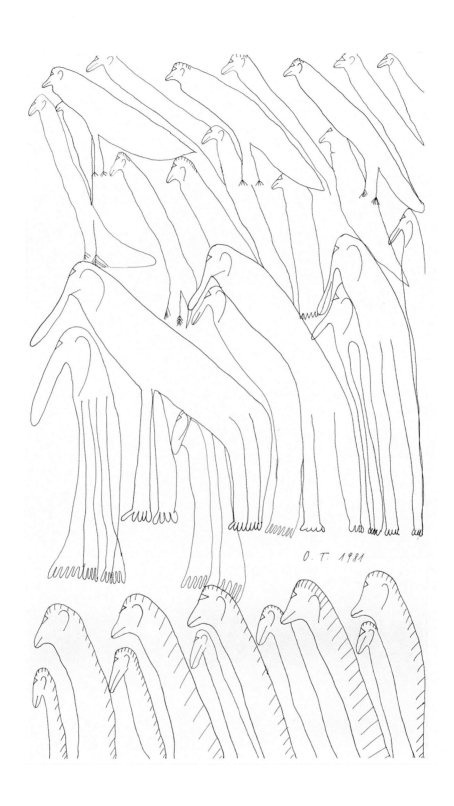

122 ELEPHANTS, 1981 · India ink on paper · 23½ x 13½ in. (59.7 x 34.3 cm)

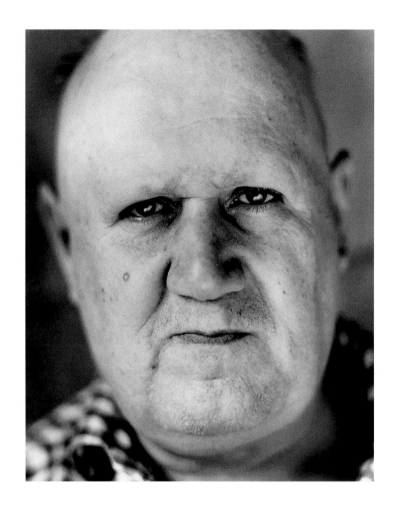

AUGUST WALLA (B. 1936)

AUGUST WALLA was born in Austria and reared by his mother and grandmother after his father's death. At the age of nine he began evincing symptoms of mental instability, which resulted in his confinement in a psychiatric clinic when he was sixteen. Upon his release four years later Walla was cared for by his devoted mother. They lived near Vienna in a house that Walla painted with symbols and words. He began receiving treatment at the Klosterneuburg Hospital in 1970, and he and his mother both moved there in 1983 (Walla now lives in the Haus der Künstler [Artists' House]). His work consistently focuses on the written word, ranging between proclamations on religious and political topics and indecipherable neologisms. His drawings, lithographs, and paintings are characterized by a bold, colorful approach to the human figure (frequently his mother). His work also includes photographs, posters, and signs painted on any available surface.

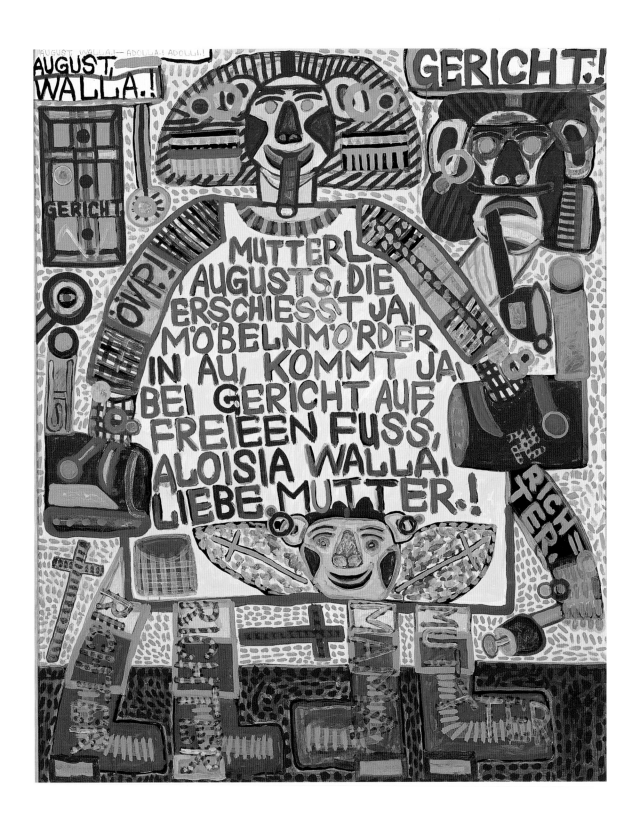

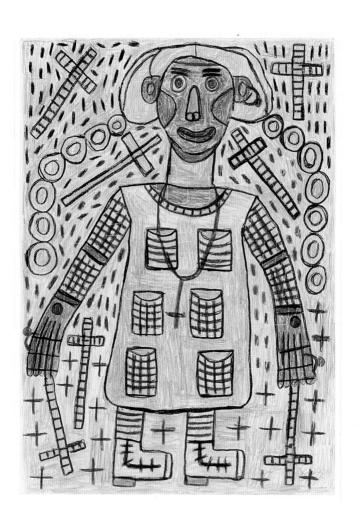

124 UNTITLED, 1995 · Pencil and colored pencil on card · 11⅝ × 8¾ in. (29.5 × 22.2 cm)

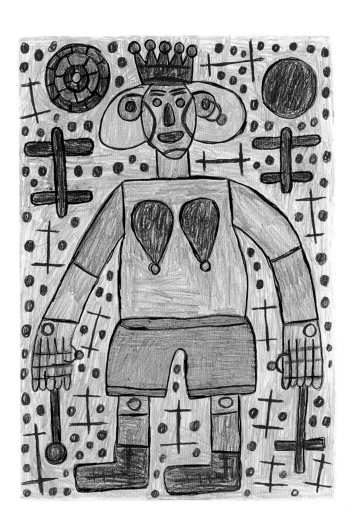

125 UNTITLED, 1995 · Pencil and colored pencil on card · 11⅝ x 8¾ in. (29.5 x 22.2 cm)

173

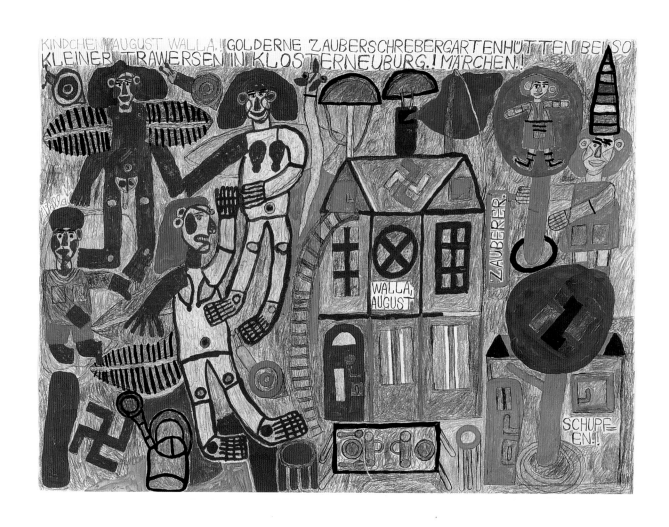

126 GOLDERNE ZAUBERSCHREBERGARTENHÜTTE, 1985? · Pencil, colored pencil, pen, and tempera on paper

21⅛ x 28⅝ in. (53.7 x 72.7 cm)

ALFRED WALLIS (1855–1942)

BORN INTO a poor family in Devonport, England, and uneducated, Alfred Wallis worked as a cabin boy and cook on coastal ships. In 1875 he married a widow who was twenty-one years his senior and had seventeen children. In 1890 they opened a marine store in the coastal town of St. Ives, Cornwall, which they operated for twenty-two years. After his wife died in 1922 the sixty-seven-year-old Wallis began to paint to overcome his loneliness. The sea was an integral part of his life, and images of boats, townscapes, and harbor scenes from St. Ives dominate his works. He painted very directly, with little regard for traditional conventions such as perspective. If he could not paint something from his viewpoint, he simply turned the board around and painted the image upside-down. Wallis's work came to the attention of the English artists Ben Nicholson and Christopher Wood in 1928. They were influenced by his paintings and promoted his work to their colleagues, the so-called St. Ives Group. Wallis was living in a public workhouse when he died.

SOMETIME in the 1940s my husband, the painter Adrian Stokes, and I decided to walk to St. Ives from Carbis Bay to see Alfred Wallis. Ben Nicholson, who discovered the talented Wallis, arrived as we were leaving and decided to come with us. "The last time I saw Wallis," he said, "he told me, 'I won't be here the next time you come to see me.'" We were angry with Ben because he hadn't made any provisions for Wallis's care, so we drove to get there sooner. When we arrived at Wallis's house we saw his paintings piled up on the table, but there was no sign of him anywhere.

I began to feel a nip-nip on my legs and complained that I was being bitten. Ben and Adrian thought I was imagining it, but when I looked down I saw that my navy trousers had turned reddish-brown. Fleas were swarming up my legs! Then Ben and Adrian were attacked too, so we quickly piled all the paintings into our car and headed home. On the way Ben insisted that we stop the car. He got out and, completely dressed, walked directly into the sea, where he stayed until all the fleas had died. We, on the other hand, were plagued by fleas for another six months!

Upon investigation as to Wallis's whereabouts we found that, due to failing health and lack of funds, he had been placed in the workhouse at the Madron Institution. Unfortunately, there was nothing we could do to extricate him, even after we explained to the director that Wallis was an important painter. Wallis was well respected and continued to draw until his death, but it took another twenty years before people began to appreciate his work.

—MARGARET MELLIS, friend

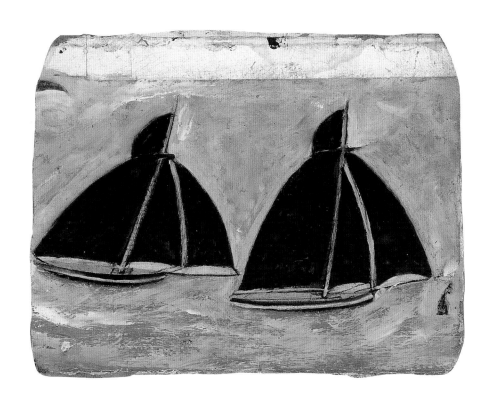

127 SCHOONERS, ca. 1939 · Oil and pencil on cardboard · 6⅛ x 10 in. (15.6 x 25.4 cm)

128 ROAD WITH HOUSES, ca. 1942 · Oil on cardboard · 16½ x 25 in. (41.9 x 63.5 cm)

129 THROUGH THE TREES, 1940 · Oil and pencil on board · 8¼ x 11¼ in. (21.0 x 28.6 cm)

130 PORT ST. IVES, ca. 1939 · Oil and pencil on paper · 6 x 9 in. (15.2 x 22.9 cm)

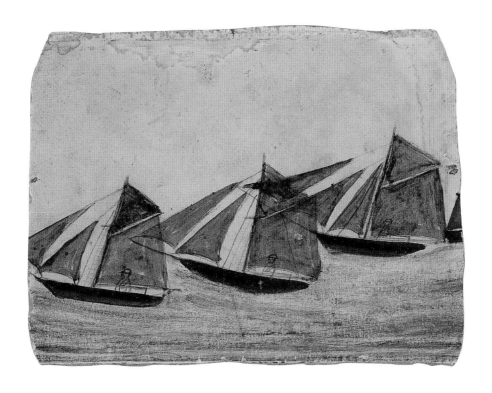

131 GREEN SAILS, ca. 1939 · Watercolor and pencil on cardboard · 7½ x 10 in. (19.1 x 25.4 cm)

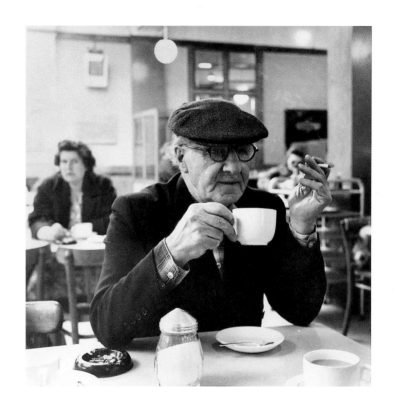

SCOTTIE WILSON (1888–1972)

SCOTTIE WILSON (né Louis Freeman) was born of Lithuanian immigrant parents in London's East End. His family settled in Glasgow, Scotland, where he left school at the age of nine to work as a paperboy. When he was eighteen he joined the Scottish Rifles and served in India, South Africa, and on the Western Front during World War I. After the war he moved to Canada, where he eventually settled in Toronto and operated a secondhand store. The account of his artistic beginning is legendary: One day in the back room of his shop he picked up a fountain pen and began doodling on a tabletop. He drew until the entire surface was covered, and he continued to draw for the next thirty-seven years of his life. His works include images of birds, trees, and architecture incorporated into stylized designs of densely hatched lines. In 1942 his work was noticed by a Canadian art dealer, Douglas Duncan, who organized Wilson's first solo exhibition in 1943. Wilson returned to Britain in 1945 and made his living by charging people to view his work rather than selling it, which initially he was reluctant to do. Later he consented to selling his work in galleries in London. In 1964 he made tableware designs for the Royal Worcester Porcelain Company. He settled in Kilbourn, London, in a single room, where he drew until his death.

EARLY IN the 1950s Jean Dubuffet, who coined the term *art brut* and was already a collector of Scottie Wilson's drawings, resolved to finally meet the artist after seeing his work at a surrealist exhibition in Paris. When Wilson received Dubuffet's letter inviting him to Paris and asking him to bring his portfolio, he didn't know anything about Dubuffet or *art brut*, but the prospect of selling his drawings appealed to him. Since I was a close friend of Scottie, he insisted that I accompany him. Like a cat, he was always wary of strangers.

When we arrived, not only was Dubuffet waiting but Pablo Picasso was with him. Both owned a few of Scottie's pieces, and Picasso had come to see—and perhaps buy—some more. I vividly remember both artists eagerly admiring Scottie's work, squabbling in their fierce, theatrical, Gallic voices over who would buy which piece. Scottie accepted their homage with a grin but was somewhat matter-of-fact, as he would be with any interested buyer.

Looking back, I realize that Scottie's reluctant excursion to Paris was one of the defining moments in the exploration of outsider art and that Picasso played an important role, hitherto unrecorded, as confidant and collaborator in the early evolution of this genre.

—BILL HOPKINS, art critic

133 TOWER OF LIGHT, ca. 1935–45 · Colored pencil and ink on paper · 14¾ x 10½ in. (37.5 x 26.7 cm)

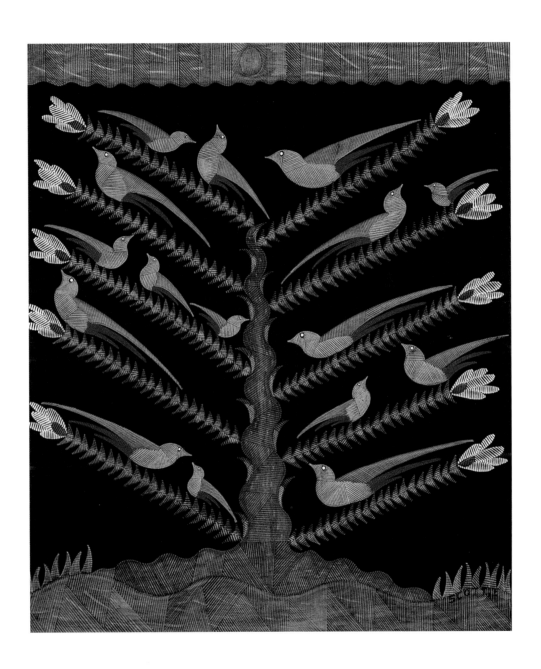

134 YELLOW BIRDS IN THE TREE, ca. 1960 · Felt-tip pen on black paper · 23½ x 20 in. (59.7 x 50.8 cm)

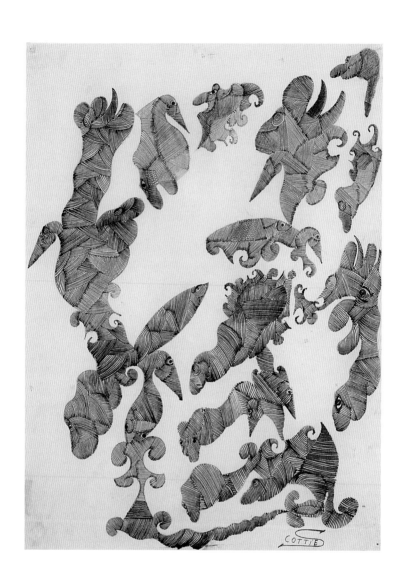

135 HERD OF GREEDIES, ca. 1929–42 · Pencil, colored pencil, and ink on paper · 15 X 11 in. (38.1 X 27.9 cm)

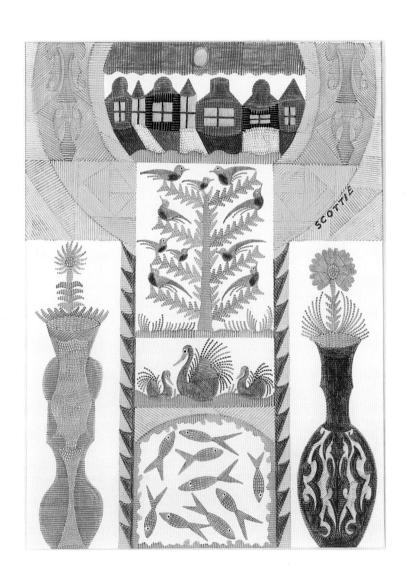

136 UNTITLED, ca. 1965 · Colored ink on paper · 14¾ x 10⅞ in. (37.5 x 27.6 cm)

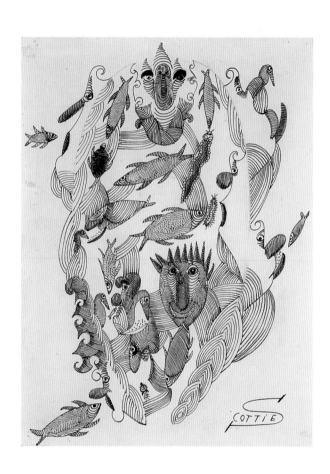

137 UNTITLED, ca. 1930 · Pen, ink, and crayon on paper · 11⅝ x 8½ in. (29.5 x 21.6 cm)

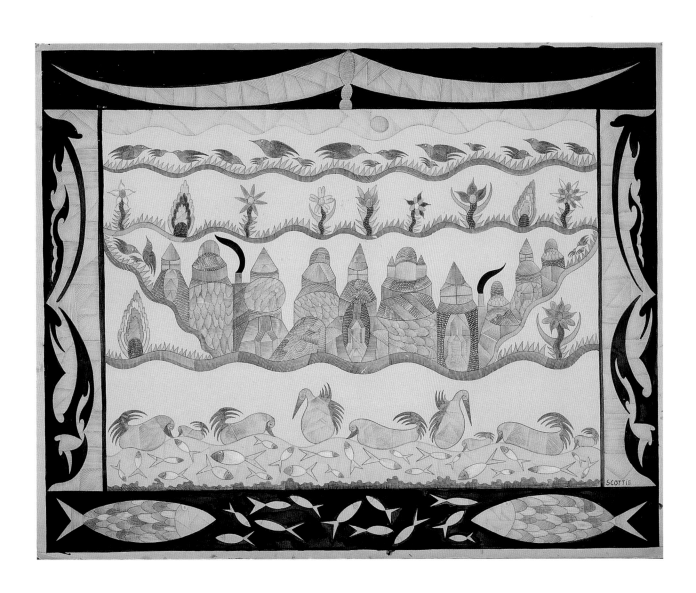

138 SPRING, ca. 1960 · Colored ink on paper · 26⅜ x 33⅛ in. (67.0 x 84.1 cm)

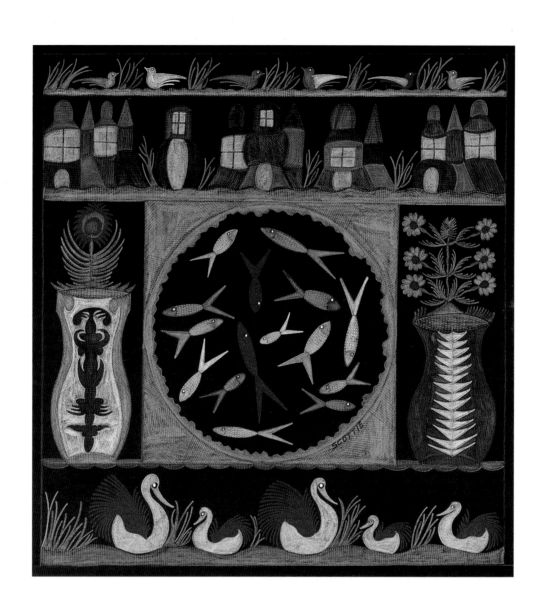

139 UNTITLED, ca. 1960 · Pencil, colored pencil, and watercolor on black paper · 23½ x 20 in. (59.7 x 50.8 cm)

ADOLF WÖLFLI (1864–1930)

ADOLF WÖLFLI, born near Bern, Switzerland, suffered many emotional hardships during his lifetime. At the age of eight, after his mother became ill, he was taken from her and sent to live with and work for various farming families in the community. Wölfli was prone to acts of violence and sexual aggression, which eventually landed him in prison. In 1895 he was diagnosed as schizophrenic and sent to the Waldau Psychiatric Clinic in Bern, where he spent much of his time in solitary confinement. There he began drawing, writing, and composing music, activities that were encouraged by the staff as a means of controlling his violent nature. Like the works of Henry Darger, Wölfli's drawings are illustrated accompaniments of a literary source, in this case his autobiography. The obsessive detail and delineating borders that mark his drawings reveal his desire for organization and control. Wölfli remained at the Waldau Clinic until his death. In 1975 the Adolf Wölfli Foundation was created, and Wölfli's tremendous collection of writings and drawings was transferred from the clinic to the Kunstmuseum in Bern.

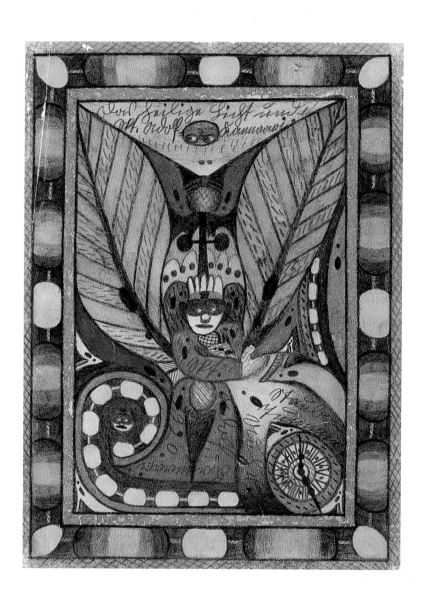

140 ANGEL, 1920 · Pencil and colored pencil on paper · 13½ x 10 in. (34.3 x 25.4 cm)

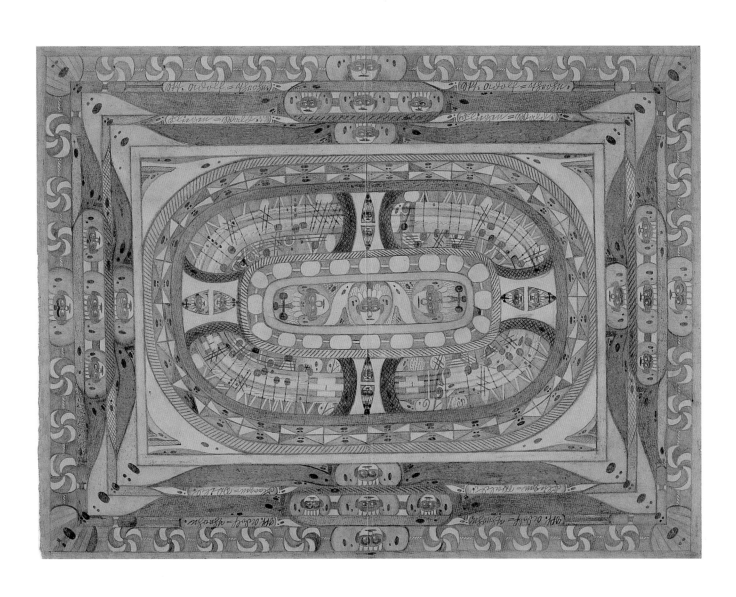

141 FLIEGIN-WALD, ca. 1921 · Pencil and colored pencil on paper · 19¾ x 26¼ in. (50.2 x 66.7 cm)

JOSEPH E. YOAKUM (1890–1972)

BORN AND REARED on his parents' Missouri farm, Joseph E. Yoakum attended school for just six months and ran away with the circus at the age of fifteen. After leaving the circus he traveled around the world as a stowaway, reportedly visiting every continent except Antarctica by 1911. He served in World War I and was stationed in Clermont-Ferrand, France. In the late 1950s Yoakum and his second wife moved to Chicago, where he claimed he operated an ice cream parlor before retiring. Around 1962 he was inspired by a dream and began drawing landscapes of the countless places he had seen, both in his travels and in his imagination. His landscapes are comprised of strong lines and rhythmic patterns, which give his drawings a forceful sense of movement. Yoakum titled his drawings very specifically and often dated them with a rubber stamp. His work is greatly admired by the group of artists known as the Chicago Imagists, including Roger Brown, Gladys Nilsson, and Jim Nutt.

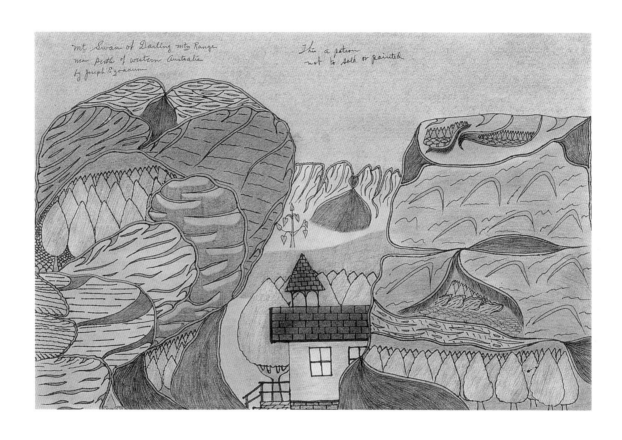

142 MT. SWAN OF DARLING MTN. RANGE NEAR PERTH OF WESTERN AUSTRALIA, 1968

Pen, pastel, and colored pencil on paper • 12 x 18 in. (30.5 x 45.7 cm)

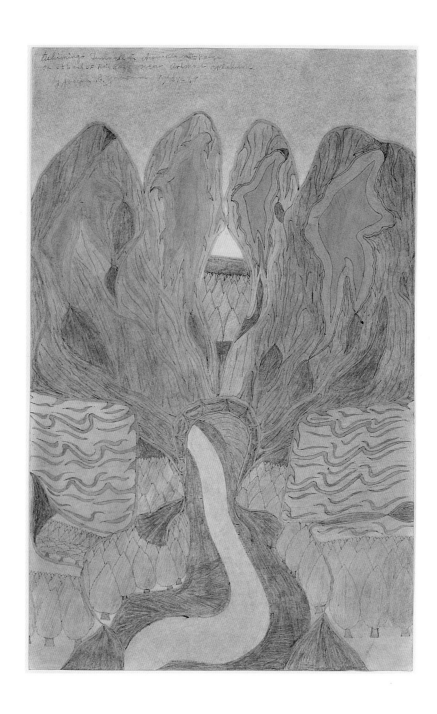

143 TISHMINGO TUNNEL IN ARBUCKLE MTN. RANGE, 1969 · Ink and colored pencil on paper · 19 x 12¼ in. (48.3 x 31.3 cm)

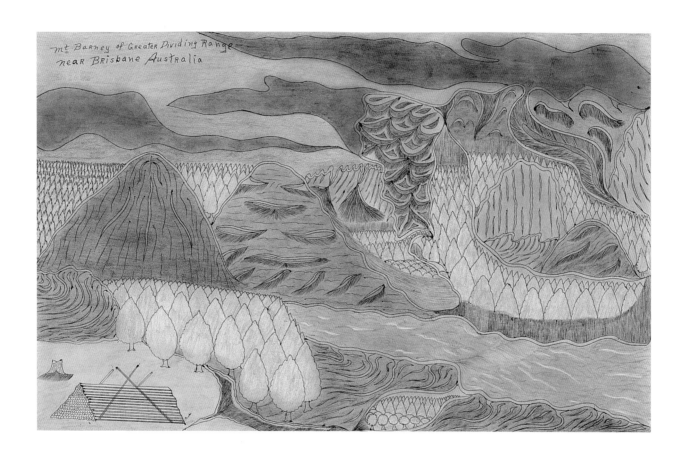

144 MT. BARNEY OF GREATER DIVIDING RANGE NEAR BRISBANE, AUSTRALIA, 1966

Colored pencil on paper · 12 x 19 in. (30.5 x 48.3 cm)

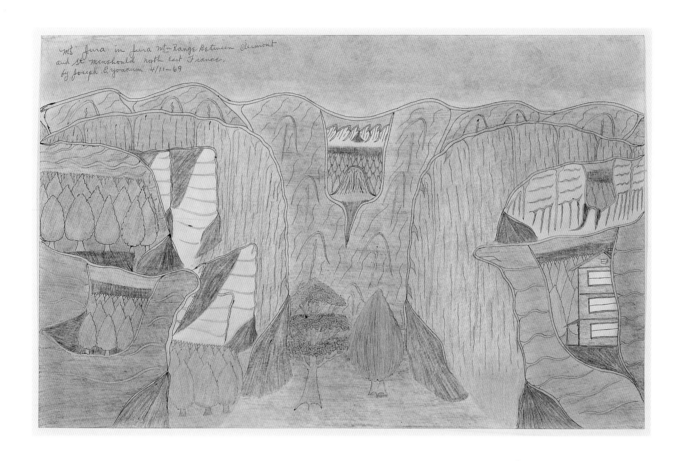

145 MT. JURA IN JURA MTN. RANGE, 1969 · Ink and colored pencil on paper · 12 x 18½ in. (30.5 x 47.0 cm)

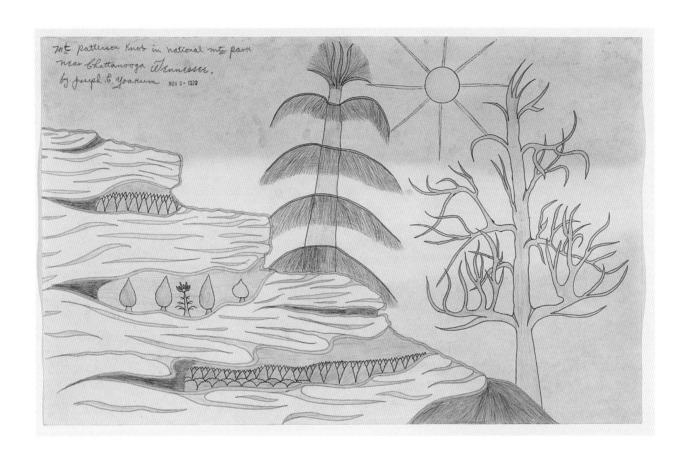

146 MT. PATTERSON KNOB IN NATIONAL MTN. PARK NEAR CHATTANOOGA, TN, 1970

Colored pencil and pastel on paper · 12 x 19 in. (30.5 x 48.3 cm)

ANNA ZEMÁNKOVÁ (1908–86)

GROWING UP in Moravia (the present-day Czech Republic), Anna Zemánková had an interest in drawing but was discouraged by her father, who suggested she study dentistry. She followed his advice and worked as a dental technician until she married and had a family, moving with them to Prague in 1948. After her children were grown, Zemánková revisited her interest in drawing at the urging of one her sons, himself an artist. Drawing became a means of coping with the bouts of depression that plagued her. She worked during the early morning hours, between four and seven o'clock, because that was when she felt "free from all cares." She described her drawing process as something that was almost beyond her control; she said that her works "seemed to draw themselves." The organic plant forms that dominate her drawings fuse botanical fact with pure invention to form fantastical images of nature.

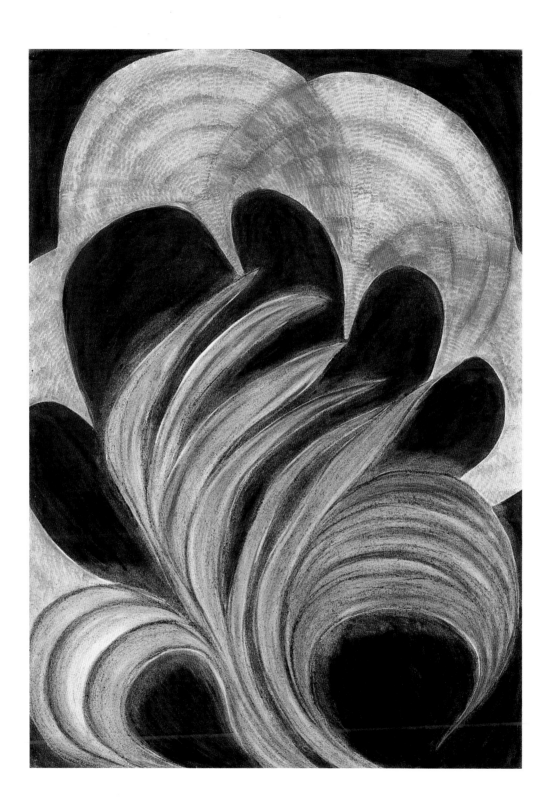

147 UNTITLED, n.d. • Pastel on paper • 33 × 23¼ in. (83.8 × 59.1 cm)

ANNA ZEMÁNKOVÁ spent her adult life in the city of Prague. Many of her creative days occurred during the grim period of the Communist occupation. With beautiful architecture and gardens everywhere, the city provided an inspiring, visually rich landscape. It was part of her daily life, as were exquisite Bohemian glass and old textile traditions of intricate embroidery.

Anna immensely enjoyed the drawings and collages she created. She found that she could shred brightly colored plastic twine and use it in her work, adding intense color, depth, and a good amount of surprise. Colored twine appealed to her so much that she embroidered many of her hats with it and looked all the more forward to her daily excursions in her exotic, flamboyant, often humorous chapeaus. The contrast of these creations with her sensible shoes made her even more of a curiosity.

The complexity of her artistic style and a rich, full life found turbulent resolution in her unique drawings. I thank her for the gifts of unparalleled beauty she left behind.

—SHARI CAVIN, art gallery owner

148 Detail of no. 149

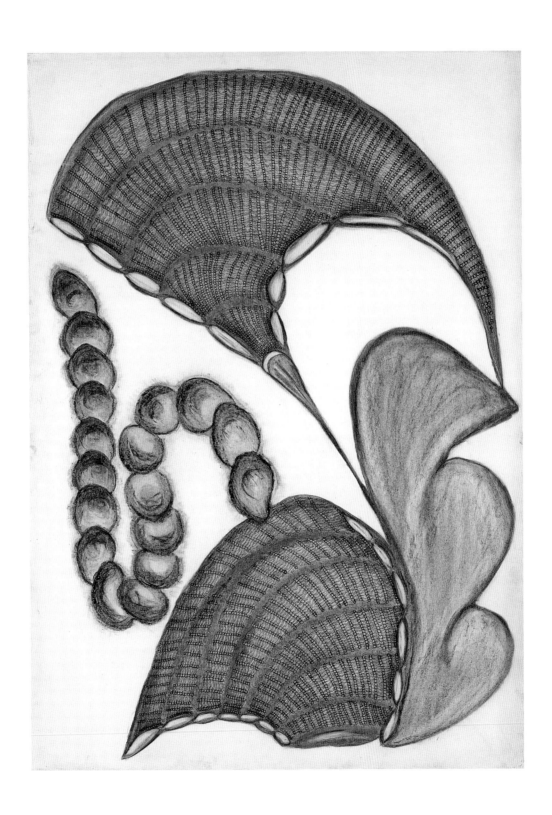

149 UNTITLED, n.d. · Pastel on paper · 34¾ x 24½ in. (88.3 x 62.2 cm)

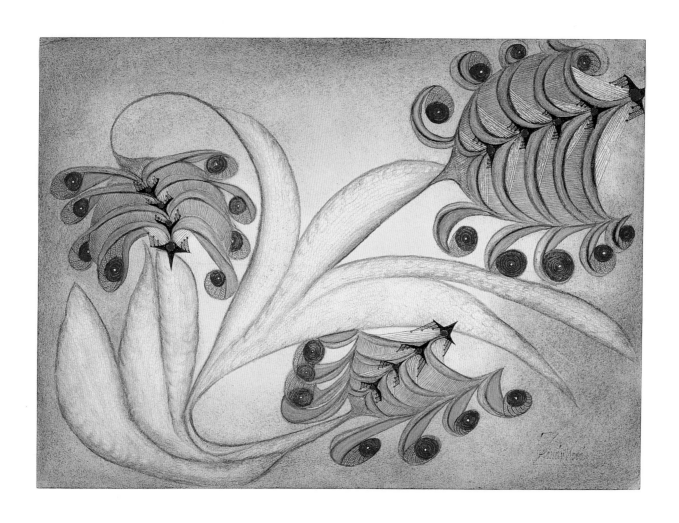

150 UNTITLED, ca. 1960s · Pastel on paper · 17½ x 24½ in. (44.5 x 62.2 cm)

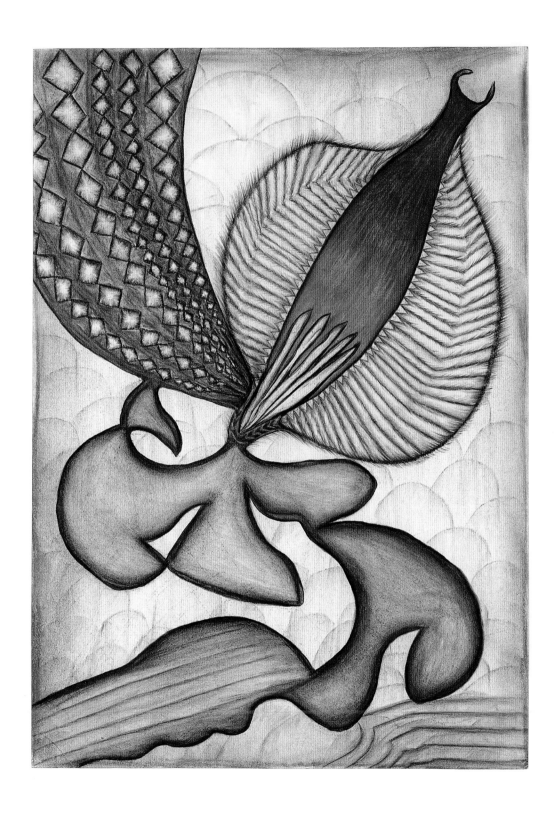

151 UNTITLED, n.d. • Pastel on paper • 33 x 23¼ in. (83.8 x 59.1 cm)

Exhibition Histories

COMPILED BY MARGARET ANDERA

CONSUELO "CHELO" GONZÁLEZ AMÉZCUA
SELECTED SOLO EXHIBITIONS: Marion Koogler McNay Art Institute, San Antonio, Tex., 1968;
Springfield Museum of Fine Arts, Springfield, Mass., 1969; Galerias Paco, New York, N.Y., 1977
SELECTED GROUP EXHIBITIONS: *Texas Folk Art: 150 Years of Southwest Tradition*, San Antonio
Museum Association, San Antonio, Tex., 1981; *The Latin-American Spirit*, Bronx Museum of the Arts,
Bronx, N.Y., 1988; *Driven to Create: The Anthony Petullo Collection of Self-Taught and Outsider Art*,
Milwaukee Art Museum, Milwaukee, Wis., 1993; *From Heart to Hand: New Ancient Ideas by Self-Taught
Artists*, Cavin-Morris Gallery, New York, N.Y., 1998

EDDIE ARNING
SELECTED SOLO EXHIBITIONS: The Abby Aldrich Rockefeller Folk Art Center, Williamsburg,
Va., 1985; Hirschl & Adler Folk, New York, N.Y., 1988
SELECTED GROUP EXHIBITIONS: *Contemporary American Folk and Naive Art*, School of the Art
Institute of Chicago, Ill., 1978; *American Folk Art: The Herbert Waide Hemphill Jr. Collection*, Milwaukee
Art Museum, Milwaukee, Wis., 1981; *Made with Passion*, National Museum of American Art,
Smithsonian Institution, Washington, D.C., 1990; *Driven to Create: The Anthony Petullo Collection of
Self-Taught and Outsider Art*, Milwaukee Art Museum, 1993; *Passionate Visions of the American South:
Self-Taught Artists from 1940 to the Present*, New Orleans Museum of Art, New Orleans, La., 1993;
Self-Taught Artists of the 20th Century, Museum of American Folk Art, New York, N.Y., 1998

CARLO (CARLO ZINELLI)

SELECTED SOLO EXHIBITIONS: Collection de l'Art Brut, Lausanne, Switzerland, 1985; Museo di Castelvecchio, Verona, Italy, 1992; Ginza Art Space, Tokyo, Japan, 1995, Carlo Foundation, San Giovanni Lupatoto, Italy, 1997; Phyllis Kind Gallery, New York, N.Y., 1994, 1998

SELECTED GROUP EXHIBITIONS: Galleria Venezia, Milan, 1968; Cordier and Egstom Gallery, New York, N.Y., 1968; *Parallel Visions: Modern Artists and Outsider Art*, Los Angeles County Museum of Art, Los Angeles, Calif., 1992; *Driven to Create: The Anthony Petullo Collection of Self-Taught and Outsider Art*, Milwaukee Art Museum, Milwaukee, Wis., 1993

HENRY DARGER

SELECTED SOLO EXHIBITIONS: Hyde Park Art Center, Chicago, Ill., 1977; University of Iowa Museum of Art, Iowa City, 1996; Museum of American Folk Art, New York, N.Y.

SELECTED GROUP EXHIBITIONS: *Outsider Art in Chicago*, Museum of Contemporary Art, Chicago, Ill., 1979; *Outsiders*, Hayward Gallery, London, England, 1979; *Transmitters: The Isolate Artist in America*, Philadelphia College of Art, Philadelphia, Pa., 1981; *In Another World*, The South Bank Centre, London, England, 1987; *Parallel Visions: Modern Artists and Outsider Art*, Los Angeles County Museum of Art, Los Angeles, Calif., 1992; *Driven to Create: The Anthony Petullo Collection of Self-Taught and Outsider Art*, Milwaukee Art Museum, Milwaukee, Wis., 1993; *Self-Taught Artists of the 20th Century*, Museum of American Folk Art, 1998; *We Are Not Alone: Angels and Other Aliens*, American Visionary Art Museum, Baltimore, Md., 1999

JAMES DIXON

SELECTED SOLO EXHIBITIONS: Portal Gallery, London, England, 1966

SELECTED GROUP EXHIBITIONS: Austin Desmond Fine Art, London, England, 1990; RONA Gallery, London, England, 1991; Alex Gerrard Fine Art Gallery, Battle, England, 1991; *Driven to Create: The Anthony Petullo Collection of Self-Taught and Outsider Art*, Milwaukee Art Museum, Milwaukee, Wis., 1993; *Sacred Waters: A Tribute to the 20th Century, Outsider and Sea*, South Street Seaport Museum, New York, N.Y., 1996

MINNIE EVANS

SELECTED SOLO EXHIBITIONS: Whitney Museum of American Art, New York, N.Y., 1975; North Carolina Museum of Art, Raleigh, 1987; High Museum of Art, Atlanta, Ga., 1993; Museum of American Folk Art, New York, N.Y., 1995

SELECTED GROUP EXHIBITIONS: *Twentieth-Century Folk Art*, Museum of American Folk Art, 1970; *Two Hundred Years of Black Art in America*, Los Angeles County Museum of Art, Los Angeles, Calif., 1976; *Muffled Voices: Folk Artists in Contemporary America*, Museum of American Folk Art, 1986; *Black Art: Ancestral Legacy*, Dallas Museum of Art, Dallas, Tex., 1990; *Passionate Visions of the American South: Self-Taught Artists from 1940 to the Present*, New Orleans Museum of Art, New Orleans, La., 1993

JOHANN FISCHER

SELECTED GROUP EXHIBITIONS: Museum Moderner Kunst, Vienna, Austria, 1983; Rosa Esman Gallery, New York, N.Y., 1986; Galerie Susanne Zander, Cologne, Germany, 1989; Collection de l'Art Brut, Lausanne, Switzerland, 1990; *Die Künstler aus Gugging* (The artists of Gugging), Moore College of Art, Philadelphia, Pa., 1991; *Driven to Create: The Anthony Petullo Collection of Self-Taught and Outsider Art*, Milwaukee Art Museum, Milwaukee, Wis., 1993; *Die Künstler aus Gugging*, Städtische Galerie, Goppingen, Germany, 1997

JOHANN GARBER

SELECTED SOLO EXHIBITIONS: Galerie Heike Curtze, Vienna, Austria, 1982

SELECTED GROUP EXHIBITIONS: Galerie Heike Curtze, 1982; Museum Moderner Kunst, Vienna, Austria, 1983; Collection de l'Art Brut, Lausanne, Switzerland, 1985; Northern Illinois University, DeKalb, 1988; Stadtmuseum Oldenburg, Oldenburg, Germany, 1989; *Die Künstler aus Gugging* (The artists of Gugging), Moore College of Art, Philadelphia, Pa., 1991; *Driven to Create: The Anthony Petullo Collection of Self-Taught and Outsider Art*, Milwaukee Art Museum, Milwaukee, Wis., 1993; *Die Künstler aus Gugging*, Städtische Galerie, Goppingen, Germany, 1997

MADGE GILL

SELECTED SOLO EXHIBITIONS: Grosvenor Gallery, London, England, 1968; Slater Art Gallery, Canterbury, England, 1972; Fine Arts Center, Washington State University, University Park, 1974; Collection de l'Art Brut, Lausanne, Switzerland, 1978; Art en Marge, Brussels, Belgium, 1987

SELECTED GROUP EXHIBITIONS: *Outsiders*, Hayward Gallery, London, England, 1979; *Aftermath*, Barbican Centre, London, England, 1982; *In Another World: Outsider Art from Europe and America*, The South Bank Centre, London, England, 1987; *Parallel Visions: Modern Artists and Outsider Art*, Los Angeles County Museum of Art, Los Angeles, Calif., 1992; *Driven to Create: The Anthony Petullo Collection of Self-Taught and Outsider Art*, Milwaukee Art Museum, Milwaukee, Wis., 1993

WILLIAM HAWKINS

SELECTED SOLO EXHIBITIONS: Ricco/Johnson Gallery, New York, N.Y., 1984; Janet Fleisher Gallery, Philadelphia, Pa., 1986; Tarble Arts Center, Eastern Illinois University, Charleston, Ill., 1989; Columbus Museum of Art, Columbus, Ohio, 1990; Museum of American Folk Art, New York, N.Y., 1997

SELECTED GROUP EXHIBITIONS: *Since the Harlem Renaissance*, Center Gallery of Bucknell University, Lewisburg, Pa., 1984; *Liberties with Liberty*, Museum of American Folk Art, 1986; *Made with Passion*, National Museum of American Art, Smithsonian Institution, Washington, D.C., 1990; *Driven to Create: The Anthony Petullo Collection of Self-Taught and Outsider Art*, Milwaukee Art Museum, Milwaukee, Wis., 1993; *Passionate Visions of the American South: Self-Taught Artists from 1940 to the Present*, New Orleans Museum of Art, New Orleans, La., 1993; *Flying Free: Twentieth-Century Self-Taught Art from the Collection of Ellin and Baron Gordon*, Abby Aldrich Rockefeller Folk Art Center, Williamsburg, Va., 1997; *Self-Taught Artists of the 20th Century*, Museum of American Folk Art, 1998

PATRICK HAYMAN

SELECTED SOLO EXHIBITIONS: Robin Nance Gallery, St. Ives, England, 1951; Gallery One, London, England, 1954; Portal Gallery, London, England, 1961; Whitechapel Art Gallery, London, England, 1973; University of Saskatchewan, Saskatoon, 1974; Galerie Legard, Wellington, New Zealand, 1985; Camden Arts Centre, London, England, 1990

SELECTED GROUP EXHIBITIONS: *British Abstract Art*, Gimpel Fils, London, England, 1951; *Alive to It All*, Serpentine Gallery, London, England, 1983; *St. Ives, 1939–64: Twenty-five Years of Painting, Sculpture, and Pottery*, Tate Gallery, London, England, 1985; *Alfred Wallis and Patrick Hayman*, Crane Kalman Gallery, London, England, 1995

JOHN KANE

SELECTED SOLO EXHIBITIONS: Contemporary Arts Gallery, New York, N.Y., 1931; Gallery 144, New York, N.Y., 1932, 1934; Carnegie Institute, Pittsburgh, Pa., 1936, 1985; M. Knoedler & Co., London, England, 1936; ACA Galleries, New York, N.Y., 1969; Galerie St. Etienne, New York, N.Y., 1984

SELECTED GROUP EXHIBITIONS: *Twenty-sixth Annual International Exhibition of Paintings*, Carnegie Institute, 1927; *45th Annual Exhibition of American Paintings and Sculpture*, The Art Institute of Chicago, Ill., 1932; *Paintings and Sculpture from 16 American Cities*, Museum of Modern Art, New York, N.Y., 1933; *They Taught Themselves*, San Francisco Museum of Art, San Francisco, Calif., 1941; *American Painting*, Tate Gallery, London, England, 1946; *Twelve Modern American Painters and Sculptors*, Musée National d'Art Moderne, Paris, France, 1953; *The Sidney and Harriet Janis Collection: A Gift to the Museum of Modern Art*, Museum of Modern Art, 1968; *The Folk Art Tradition*, Galerie St. Etienne, 1981; *American Folk Art from the Milwaukee Art Museum*, Milwaukee Art Museum, Milwaukee, Wis., 1989; *Self-Taught Artists of the 20th Century*, Museum of American Folk Art, New York, N.Y., 1998

ROSEMARIE KOCZY

SELECTED SOLO EXHIBITIONS: Musée Athénée, Geneva, Switzerland, 1970, 1979; Collection de l'Art Brut, Lausanne, Switzerland, 1985; Zolla-Lieberman Gallery, Chicago, Ill., 1985; Galeries Carré Noir et Carré Blanc, Nyon, Switzerland, 1987, 1988, 1989; Galerie Michael Haas, Berlin, Germany, 1990; Galerie Imago, Bègles, France, 1991

SELECTED GROUP EXHIBITIONS: Musée Jenisch, Vevey, Switzerland, 1968; Solomon R. Guggenheim Museum, New York, N.Y., 1982, 1983; *Outsider Art from Europe,* University of Connecticut, Storrs, 1988; *Portraits from the Outside,* Parsons School of Design, New York, N.Y., 1990; *Särlingar: Art Brut/Outsider Art,* Malmö Konsthall, Malmö, Sweden, 1991; *Driven to Create: The Anthony Petullo Collection of Self-Taught and Outsider Art,* Milwaukee Art Museum, Milwaukee, Wis., 1993; *L'Exposition Art Brut et Compagnie,* La Halle Saint-Pierre et le Musé d'Art Naïf Max Fourny, Paris, France, 1995

HALINA KORN

SELECTED SOLO EXHIBITIONS: Mayor Gallery, London, England, 1948; Gallery One, London, England, 1960; New Artists' Forum, London, England, 1965; B. W. A. Gallery, Gdynia, Poland, 1967; B. W. A. Gallery, Katowice, Poland, 1968

MÅNA LAGERHOLM

SELECTED SOLO EXHIBITIONS: Mercury Gallery, London, England, 1977; Deux Tetes Gallery, Toronto, Ontario, 1978; Chapman Gallery, Canberra, Australia, 1981; Rye Art Gallery, Rye, England, 1982

SELECTED GROUP EXHIBITIONS: Royal Academy of Art, London, England, 1978

SYLVIA LEVINE

SELECTED SOLO EXHIBITIONS: Terracotta Gallery, Bradford-on-Avon, England, 1961; Turtle Gallery, Cheltenham, England, 1988; Talent Gallery, London, England, 1988

SELECTED GROUP EXHIBITIONS: *The Young Contemporaries,* The Mall Galleries, London, England, 1956; Royal West of England Annual Exhibitions, Bristol, England, 1963, 1980, 1982, 1985, 1991; Royal Academy Summer Exhibitions, London, England, 1977, 1980, 1982, 1985, 1988, 1991, 1992; Rooksmoor Gallery, Bath, England, 1986; Nevill Gallery, Bath, England, 1987; RONA Gallery, London, England, 1991; Alex Gerrard Fine Art Gallery, Battle, England, 1991, 1993; *Driven to Create: The Anthony Petullo Collection of Self-Taught and Outsider Art,* Milwaukee Art Museum, Milwaukee, Wis., 1993

JAMES LLOYD

SELECTED SOLO EXHIBITIONS: Arthur Jeffress Gallery, London, England, 1958; Portal Gallery, London, England, 1964, 1966, 1968, 1971; Camden Arts Centre, London, England, 1977

SELECTED GROUP EXHIBITIONS: *Naivi '73,* Zagreb Die Kunst der Naiven, Yugoslavia, 1973; *Body and Soul,* Walker Art Gallery, Liverpool, England, 1976

ALBERT LOUDEN

SELECTED SOLO EXHIBITIONS: Serpentine Gallery, London, England, 1985; Prema Project, Dursley, England, 1985; Rosa Esman Gallery, New York, N.Y., 1986; Art en Marge, Brussels, Belgium, 1987; Galerie Jean-Pierre Harter, Paris, France, 1992

SELECTED GROUP EXHIBITIONS: *Outsiders: Art Beyond the Norms,* Rosa Esman Gallery, 1986; *In Another World: Outsider Art from Europe and America,* The South Bank Centre, London, England, 1987; *Portraits from the Outside,* Parsons School of Design, New York, N.Y., 1990; *Outsider Art,* Alpha Cubic Gallery, Tokyo, Japan, 1990; *Création Franche,* Bègles, France, 1993; *Driven to Create: The Anthony Petullo Collection of Self-Taught and Outsider Art,* Milwaukee Art Museum, Milwaukee, Wis., 1993

DWIGHT MACKINTOSH

SELECTED SOLO EXHIBITIONS: Creative Growth Art Center, Oakland, Calif., 1992; Musée L'Art Brut, Lausanne, Switzerland, 1992; Art en Marge, Brussels, Belgium, 1993

SELECTED GROUP EXHIBITIONS: *International Exhibition of Painting*, Richmond Art Center, Richmond, Calif., 1980; *Primal Portraits: Adam and Eve as Seen by Self-Taught 20th-Century Artists*, Craft and Folk Museum, San Francisco, Calif., 1990; *Flying Free: Twentieth-Century Self-Taught Art from the Collection of Ellin and Baron Gordon*, Abby Aldrich Rockefeller Folk Art Center, Williamsburg, Va., 1997

JAHAN MAKA

SELECTED SOLO EXHIBITIONS: Thomas Gallery, Winnipeg, Manitoba, 1978; The Upstairs Gallery, Winnipeg, Manitoba, 1978; Gallery 1.1.1, School of Art, University of Manitoba, Winnipeg, 1985; Dunlop Art Gallery, Regina, Saskatchewan, 1988

SELECTED GROUP EXHIBITIONS: *From the Heart: Folk Art in Canada*, Canadian Centre for Folk Culture Studies of the National Museum of Man, Ottawa, Ontario, 1983; *Pierre Elliot Trudeau Portraits*, Susan Whitney Gallery, Regina, Saskatchewan, 1984; *Folk Art: Manitoba, Saskatchewan, North Dakota*, The Upstairs Gallery, 1985; *Jahan Maka and Philip Melvin*, Susan Whitney Gallery, 1988; *Driven to Create: The Anthony Petullo Collection of Self-Taught and Outsider Art*, Milwaukee Art Museum, Milwaukee, Wis., 1993

JUSTIN McCARTHY

SELECTED SOLO EXHIBITIONS: Allentown Art Museum, Allentown, Pa., 1984; Cavin-Morris Gallery, New York, N.Y., 1996

SELECTED GROUP EXHIBITIONS: *Seventeen Naive Painters*, Museum of Modern Art, New York, N.Y., 1966; *Muffled Voices: Folk Artists in Contemporary America*, Museum of American Folk Art, New York, N.Y., 1986; *Made with Passion*, National Museum of American Art, Smithsonian Institution, Washington, D.C., 1990; *Driven to Create: The Anthony Petullo Collection of Self-Taught and Outsider Art*, Milwaukee Art Museum, Milwaukee, Wis., 1993; *Flying Free: Twentieth-Century Self-Taught Art from the Collection of Ellin and Baron Gordon*, Abby Aldrich Rockerfeller Folk Art Center, Williamsburg, Va., 1997; *Self-Taught Artists of the 20th Century*, Museum of American Folk Art, 1998

MICHEL NEDJAR

SELECTED SOLO EXHIBITIONS: Godula Bucholz Werkraum Gallery, Munich, Germany, 1981; Rosa Esman Gallery, New York, N.Y., 1986; Susanne Zander Gallery, Cologne, Germany, 1988, 1989; Le Gall Peyroulet Gallery, Paris, France, 1991; Carl Hammer Gallery, Chicago, Ill., 1993; Galerie St. Etienne, New York, N.Y., 1997

SELECTED GROUP EXHIBITIONS: *Les Singuliers de l'Art*, ARC–Musée de l'Art Moderne de la Ville de Paris, France, 1978; *European Outsiders*, Rosa Esman Gallery, New York, N.Y., 1986; *Outsider Art from Europe*, University of Connecticut, Storrs, 1988; *Schrift im Bild*, Susanne Zander Gallery, 1989; *Portraits from the Outside*, Parsons School of Design, New York, N.Y., 1990; *Driven to Create: The Anthony Petullo Collection of Self-Taught and Outsider Art*, Milwaukee Art Museum, Milwaukee, Wis., 1993

NIKIFOR

SELECTED SOLO EXHIBITIONS: Galerie Dina Vierny, Paris, France, 1959

SELECTED GROUP EXHIBITIONS: *La Peinture Naïve*, Knokke-le Zoute, Belgium, 1958; *Das Naïve Bild der Welt*, Baden-Baden, Germany, 1961; *First Triennale of Insite Art*, Bratislava, Slovakia, 1966; Galerie Charlotte, Munich, Germany, 1990; RONA Gallery, London, England, 1991; *Driven to Create: The Anthony Petullo Collection of Self-Taught and Outsider Art*, Milwaukee Art Museum, Milwaukee, Wis., 1993; *Sacred Waters: A Tribute to the 20th Century, Outsider and Sea*, South Street Seaport Museum, New York, N.Y., 1996

PERIFIMOU

SELECTED GROUP EXHIBITIONS: *Outsiders*, Sao Paolo Biennial, Sao Paolo, Brazil, 1981; *Outsiders*, Prema Project, Dursley, England, 1986; *In Another World: Outsider Art from Europe and America*, The South Bank Centre, London, England, 1987; *Outsider Art*, Alpha Cubic Gallery, Tokyo, Japan, 1990; *Outsider Art*, Café Gallery, London, England, 1990; *Driven to Create: The Anthony Petullo Collection of Self-Taught and Outsider Art*, Milwaukee Art Museum, Milwaukee, Wis., 1993; *We Are Not Alone: Angels and Other Aliens*, American Visionary Art Museum, Baltimore, Md., 1999

MAX RAFFLER

SELECTED SOLO EXHIBITIONS: Günther Franke Gallery, Munich, Germany, 1968

SELECTED GROUP EXHIBITIONS: *Naive and Outsider Painting from Germany and Paintings by Gabriele Münter,* Museum of Contemporary Art, Chicago, Ill., 1983; Galerie Charlotte, Munich, Germany, 1991; Galerie Susi Brunner, Zurich, Switzerland, 1992; *Driven to Create: The Anthony Petullo Collection of Self-Taught and Outsider Art,* Milwaukee Art Museum, Milwaukee, Wis., 1993

MARTIN RAMIREZ

SELECTED SOLO EXHIBITIONS: Moore College of Art, Philadelphia, Pa., 1985; Centro Cultural/Arte Contemporáno, Mexico City, Mexico, 1989

SELECTED GROUP EXHIBITIONS: *Contemporary American Folk and Naive Art,* School of the Art Institute of Chicago, Ill., 1978; *Outsiders,* Hayward Gallery, London, England, 1979; *Muffled Voices: Folk Artists in Contemporary America,* Museum of American Folk Art at the Paine Webber Art Gallery, New York, N.Y., 1986; *Five Star Folk Art: One Hundred American Masterpieces,* Museum of American Folk Art, 1990; *Made with Passion,* National Museum of American Art, Smithsonian Institution, Washington, D.C., 1990; *Common Ground/Uncommon Vision: The Michael and Julie Hall Collection of American Folk Art,* Milwaukee Art Museum, Milwaukee, Wis., 1993; *Driven to Create: The Anthony Petullo Collection of Self-Taught and Outsider Art,* Milwaukee Art Museum, 1993; *Self-Taught Artists of the 20th Century,* Museum of American Folk Art, 1998

FRIEDRICH SCHRÖDER-SONNENSTERN

SELECTED SOLO EXHIBITIONS: Galerie Brockstedt, Hamburg, Germany, 1960; Aoki Gallery, Tokyo, Japan, 1964; Städtische Kunsthalle, Düsseldorf, Germany, 1967; Galerie Europa, Berlin, Germany, 1969; Kestner-Gesellschaft, Hanover, Germany, 1973

SELECTED GROUP EXHIBITIONS: *Exposition Internationale du Surréalisme,* Galerie Daniel Cordier, Paris, France, 1959; *Le Monde Naïf,* Musée Nationale de l'Art Moderne, Paris, France, 1964; *Gruppe Malerpoeten,* Freie Berliner Kunstausstellung, Berlin, Germany, 1973; *Parallel Visions: Modern Artists and Outsider Art,* Los Angeles County Museum of Art, Los Angeles, Calif., 1992; *Driven to Create: The Anthony Petullo Collection of Self-Taught and Outsider Art,* Milwaukee Art Museum, Milwaukee, Wis., 1993

JON SERL

SELECTED SOLO EXHIBITIONS: San Pedro Municipal Art Gallery, San Pedro, Calif., 1971; Cavin-Morris Gallery, New York, N.Y., 1996

SELECTED GROUP EXHIBITIONS: *Pioneers in Paradise: Folk and Outsider Artists of the West Coast,* Long Beach Museum of Art, Long Beach, California, 1984; *Muffled Voices: Folk Artists in Contemporary America,* Museum of American Folk Art, New York, N.Y., 1985; *The Cutting Edge,* Museum of American Folk Art, 1990; *Flying Free: Twentieth-Century Self-Taught Art from the Collection of Ellin and Baron Gordon,* Abby Aldrich Rockefeller Folk Art Center, Williamsburg, Va., 1997; *From Heart to Hand: New Ancient Ideas by Self-Taught Artists,* Cavin-Morris Gallery, 1998

BILL TRAYLOR

SELECTED SOLO EXHIBITIONS: New South Art Center, Montgomery, Ala., 1940; Montgomery Museum of Fine Arts, Montgomery, Ala., 1982, 1994; Mississippi Museum of Art, Jackson, Miss., 1983; Collection de l'Art Brut, Lausanne, Switzerland, 1993; Kunstmuseum Bern, Switzerland, 1998; Museum Ludwig, Cologne, Germany, 1999; Robert Hull Fleming Museum, Burlington, Vt., 1999

SELECTED GROUP EXHIBITIONS: *Black Folk Art in America, 1930–1980,* Corcoran Gallery of Art, Washington, D.C., 1982; High Museum of Art, Atlanta, Ga., 1983; *Since the Harlem Renaissance,* Bucknell University, Lewisburg, Pa., 1984; *Five Star Folk Art: One Hundred American Masterpieces,* Museum of American Folk Art, New York, N.Y., 1990; *Made with Passion,* National Museum of American Art, Smithsonian Institution, Washington, D.C., 1990; *Common Ground/Uncommon Vision: The Michael and Julie Hall Collection of American Folk Art,* Milwaukee Art Museum, Milwaukee, Wis., 1993; *Driven to Create: The Anthony Petullo Collection of Self-Taught and Outsider Art,* Milwaukee Art Museum, 1993; *Self-Taught Artists of the 20th Century,* Museum of American Folk Art, 1998

OSWALD TSCHIRTNER

SELECTED SOLO EXHIBITIONS: Museum de Stadshof, Zwolle, The Netherlands, 1998

SELECTED GROUP EXHIBITIONS: Galerie Nächst St. Stephan, Vienna, Austria, 1970; Staatliche Kunsthalle Baden-Baden, Germany, 1978; *Outsiders*, Hayward Gallery, London, England, 1979; Museum Moderner Kunst, Vienna, Austria, 1983; Collection de l'Art Brut, Lausanne, Switzerland, 1984; *European Outsiders*, Rosa Esman Gallery, New York, N.Y., 1986; *Die Künstler aus Gugging* (The artists of Gugging), Moore College of Art, Philadelphia, Pa., 1991; *Driven to Create: The Anthony Petullo Collection of Self-Taught and Outsider Art*, Milwaukee Art Museum, Milwaukee, Wis., 1993; *Die Künstler aus Gugging*, Städtische Galerie, Goppingen, Germany, 1997

AUGUST WALLA

SELECTED SOLO EXHIBITIONS: Museum Moderner Kunst, Vienna, Austria, 1988; Collection de l'Art Brut, Lausanne, Switzerland, 1988; Galerie Susanne Zander, Cologne, Germany, 1992, 1995

SELECTED GROUP EXHIBITIONS: Galerie Nächst St. Stephan, Vienna, Austria, 1970; *Outsiders,* Hayward Gallery, London, England, 1979; Collection de l'Art Brut, 1985; *European Outsiders*, Rosa Esman Gallery, New York, N.Y., 1986; *Die Künstler aus Gugging* (The artists of Gugging), Moore College of Art, Philadelphia, Pa., 1991; *Driven to Create: The Anthony Petullo Collection of Self-Taught and Outsider Art*, Milwaukee Art Museum, Milwaukee, Wis., 1993; *Die Künstler aus Gugging,* Städtische Galerie, Goppingen, Germany, 1997

ALFRED WALLIS

SELECTED SOLO EXHIBITIONS: Bournemouth Arts Club, Bournemouth, England, 1950; Penwith Gallery, St. Ives, England, 1959, 1968, 1974, 1983; Weddington Galleries, London, England, 1965; Tate Gallery, London, England, 1968; Mercury Gallery, Edinburgh, Scotland, 1985

SELECTED GROUP EXHIBITIONS: *Seven and Five Society*, Arthur Tooth Gallery, London, England, 1929; *Christopher Wood, Alfred Wallis from the Wertheim Collection,* Towner Art Gallery, Eastbourne, England, 1968; *Alfred Wallis, Christopher Wood, Ben Nicholson*, Pier Arts Centre, Stromness, Scotland, 1987; *Driven to Create: The Anthony Petullo Collection of Self-Taught and Outsider Art*, Milwaukee Art Museum, Milwaukee, Wis., 1993; *Alfred Wallis and Patrick Hayman*, Crane Kalman Gallery, London, England, 1995; *Sacred Waters: A Tribute to the 20th Century, Outsider and Sea*, South Street Seaport Museum, New York, N.Y., 1996

SCOTTIE WILSON

SELECTED SOLO EXHIBITIONS: Picture Loan Society, Toronto, Ontario, 1943; Galerie de France, Paris, 1952; Brook Street Gallery, London, England, 1966; Collection de L'Art Brut, Lausanne, Switzerland, 1978; Third Eye Centre, Glasgow, Scotland, 1986

SELECTED GROUP EXHIBITIONS: *Surrealist Diversity*, Arcade Gallery, London, England, 1945; *L'Art Brut*, Musée des Arts Décoratifs, Paris, France, 1967; *Näive Art in Canada,* National Gallery of Canada, Ottawa, Ontario, 1974; *Wahn oder Wirklichkeit*, Galerie Charlotte für Naive Kunst, Munich, Germany, 1980; *Outsiders: Art Beyond the Norms*, Rosa Esman Gallery, New York, N.Y., 1986; *Parallel Visions: Modern Artists and Outsider Art*, Los Angeles County Museum of Art, Los Angeles, Calif., 1992; *Driven to Create: The Anthony Petullo Collection of Self-Taught and Outsider Art*, Milwaukee Art Museum, Milwaukee, Wis., 1993

ADOLF WÖLFLI

SELECTED SOLO EXHIBITIONS: Buchhandlung Ernst Bircher, Bern, Switzerland, 1921; Galerie René Drouin (Compagnie de l'Art Brut), Paris, France, 1948; Kunstmuseum Bern, Switzerland, 1976–80; Collection de l'Art Brut, Lausanne, Switzerland, 1981; Moore College of Art, Philadelphia, Pa., 1988; Centre Culturel Suisse, Paris, France, 1991; Museum de Stadshof, Zwolle, The Netherlands, 1995; Sala 1, Rome, Italy, 1998

SELECTED GROUP EXHIBITIONS: *L'Art Brut Préféré aux Arts Culturels,* Galerie René Drouin (Compagnie de l'Art Brut), 1949; *L'Art Brut,* Musée des Arts Décoratifs, Paris, France, 1967; Documenta 5 Kassel, Germany, 1972; *Another World: Wölfli, Alöise, Müller,* Porte de la Suisse, Paris, France, 1977–79; *Der Hang Zum Gesamtkunstwerk,* Kunsthaus, Zurich, Switzerland, 1983; *Outsiders: Art Beyond the Norms,* Rosa Esman Gallery, New York, N.Y., 1986; *Parallel Visions: Modern Artists and Outsider Art,* Los Angeles County Museum of Art, Los Angeles, Calif., 1992; *Driven to Create: The Anthony Petullo Collection of Self-Taught and Outsider Art,* Milwaukee Art Museum, Milwaukee, Wis., 1993; *La Ville: Art et Architecture en Europe, 1870–1993,* Centre Georges Pompidou, Paris, France, 1994; *La Dernier Continent, ou la Waldau, Asile de l'Art,* Centre Culturel Suisse, 1996; *Art Brut,* Kyoto State Museum, Kyoto, Japan, 1997; *Discovery of Art Brut,* The Hong Kong Arts Centre, Hong Kong, 1997; *Private Worlds: Classic Outsider Artists from Europe,* Katonah Museum of Art, Katonah, N.Y., 1998–99

JOSEPH E. YOAKUM

SELECTED SOLO EXHIBITIONS: Pennsylvania State University Art Museum, University Park, 1969; School of the Art Institute of Chicago, Ill., 1971; Whitney Museum of American Art, New York, N.Y., 1972; University of Rhode Island, Kingston, 1973; The Art Institute of Chicago, Ill., 1995

SELECTED GROUP EXHIBITIONS: *Contemporary American Folk and Naive Art,* School of the Art Institute of Chicago, 1978; *Transmitters: The Isolate Artist in America,* Philadelphia College of Art, Philadelphia, Pa., 1981; *Made with Passion,* National Museum of American Art, Smithsonian Institution, Washington, D.C., 1990; *Common Ground/Uncommon Vision: The Michael and Julie Hall Collection of American Folk Art,* Milwaukee Art Museum, Milwaukee, Wis., 1993; *Driven to Create: The Anthony Petullo Collection of Self-Taught and Outsider Art,* Milwaukee Art Museum, 1993; *Flying Free: Twentieth-Century Self-Taught Art from the Collection of Ellin and Baron Gordon,* Abby Aldrich Rockefeller Folk Art Center, Williamsburg, Va., 1997; *Self-Taught Artists of the 20th Century,* Museum of American Folk Art, New York, N.Y., 1998

ANNA ZEMÁNKOVÁ

SELECTED SOLO EXHIBITIONS: High Museum of Art, Folk Art and Photography Galleries, Atlanta, Ga., 1997; Cavin-Morris Gallery, New York, N.Y., 1998

SELECTED GROUP EXHIBITIONS: *Driven to Create: The Anthony Petullo Collection of Self-Taught and Outsider Art,* Milwaukee Art Museum, Milwaukee, Wis., 1993; *From Heart to Hand: New Ancient Ideas by Self-Taught Artists,* Cavin-Morris Gallery, 1998.

Selected Bibliography

COMPILED BY MARGARET ANDERA

The following books, journal articles, and museum catalogs provided much of the material for the artists' biographies that appear throughout this work.

Abby Aldrich Rockefeller Folk Art Center. *Flying Free: Twentieth-Century Self-Taught Art from the Collection of Ellin and Baron Gordon*. Williamsburg, Va.: Colonial Williamsburg Foundation, 1997.

Allentown Art Museum. *Justin McCarthy*. Allentown, Pa.: Allentown Art Museum, 1984.

Arts Council of Great Britain. *Outsiders: An Art without Precedent or Tradition*. London: Arts Council of Great Britain, 1979.

Banach, Andrzej. *Nikifor*. Warsaw: N.p., 1982.

Berlin, Sven. *Alfred Wallis: Primitive*. London: Nicholson and Watson, 1949.

Bihalji-Merin, Oto. *Modern Primitives*. London: 1971.

Bihalji-Merin, Oto, and Nebojsa-Bato Tomasevic. *World Encyclopedia of Naïve Art*. Secaucus, N.J.: Chartwell Books, 1984.

Bonesteel, Michael, Henry Darger, and Christopher Lyon. *Henry Darger: Art and Selected Writings*. New York: Rizzoli International, 2000.

Borum, Jennifer. "The Visionary Drawings of Chelo González Amézcua." *Folk Art* 24:3 (Fall 1999): 53–61.

Camden Arts Centre. *James Lloyd, 1905–1974: Retrospective*. London: Camden Arts Centre, 1977.

Cardinal, Roger. *Outsider Art*. New York: Praeger, 1972.

Cohrs, Timothy. "Henry Darger, Artist (Outsider, Naive, Folk, Autistic or Genuine Fine)." *Arts Magazine* 61:5 (January 1987): 14–17.

Columbus Museum of Art. *Popular Images Personal Visions: The Art of William Hawkins*. Columbus, Ohio: Columbus Museum of Art, 1990.

Cross, Tom. *Painting the Warmth of the Sun: St. Ives, 1939–1975*. Cornwall: Alison Hodge, 1984.

De Passe, Derrel B. *Traveling the Rainbow: The Life and Art of Joseph E. Yoakum*. Jackson: University Press of Mississippi, 2001.

Dunlop Art Gallery. *Scottie Wilson: The Canadian Drawings*. Regina, Saskatchewan: Dunlop Art Gallery, 1989.

Everett, Peter. *The Voyages of Alfred Wallis*. London: Jonathan Cape, 1999.

Gale, Matthew. *Alfred Wallis*. London: Tate Gallery Publishing, 1998.

Galerie Susanne Zander. *Rosemarie Koczy*. Cologne: Galerie Susanne Zander, 1989.

Goldie Paley Gallery, Moore College of Art. *The Heart of Creation: The Art of Martin Ramirez*. Philadelphia: Goldie Paley Gallery, Moore College of Art, 1985.

———. *The Other Side of the Moon: The World of Adolf Wölfli*. Philadelphia: Goldie Paley Gallery, Moore College of Art, 1988.

Hartigan, Lynda Roscoe. *Made with Passion*. Washington, D.C.: Smithsonian Institution Press, 1990.

Helfenstein, Josef, and Roman Kurzmeyer, eds. *Bill Traylor, 1854–1949: Deep Blues*. New Haven, Conn.: Yale University Press, 1999.

Hemphill, Herbert W., Jr., and Julia Weissman. *Twentieth-Century American Folk Art and Artists*. New York: E. P. Dutton and Co., 1974.

Irish Museum of Modern Art. *Two Painters: Works by Alfred Wallis and James Dixon*. London: Merrell Holberton, 1999.

Jacob, Mary Jane. *Naïve and Outsider Painting from Germany*. Chicago: N.p., 1983.

Janis, Sidney. *They Taught Themselves: American Primitive Painters of the 20th Century*. 1942. Reprint, New York: Sanford L. Smith and Associates, 1999.

Johnson, Jay, and William Ketchum Jr. *American Folk Art of the Twentieth-Century*. New York: Rizzoli International, 1983.

Kernan, Nathan. "Aspects of Minnie Evans." *Art on Paper* 1:6 (July–August 1997): 12–16.

Kyoto Shoin International. *Art Random: Outsider Art*. Kyoto: Shashin Kagaku Co., 1989.

Larsen, Susan C. "Jon Serl in Person." *Folk Art* 22:4 (Winter 1997–98): 52–59.

Lipman, Jean, Robert Bishop, Elizabeth V. Warren, and Sharon L. Eisenstat. *Five Star Folk Art: One Hundred American Masterpieces*. New York: Harry M. Abrams in association with the Museum of American Folk Art, 1990.

Lister, Eric. *Portal Painters*. New York: Alpine Fine Arts, 1982.

Livingston, Jane, and John Beardsley. *Black Folk Art in America 1930–1980*. Jackson: University Press of Mississippi and the Center for the Study of Southern Culture for the Corcoran Gallery of Art, 1982.

Los Angeles County Museum of Art. *Parallel Visions: Modern Artists and Outsider Art*. Princeton, N.J.: Princeton University Press, 1992.

MacGregor, John. *Dwight Mackintosh: The Boy Who Time Forgot*. Oakland, Calif.: Creative Growth Art Center, 1990.

Maizels, John. *Raw Creation: Outsider Art and Beyond*. London: Phaidon Press, 1996.

Maresca, Frank, and Roger Ricco. *American Self-Taught: Paintings and Drawings by Outsider Artists*. New York: Alfred A. Knopf, 1993.

———. *Bill Traylor: His Art, His Life*. New York: Alfred A. Knopf, 1991.

Marzolf, Helen. *Jahan Maka: Retrospective*. Regina, Saskatchewan: Dunlop Art Museum, 1989.

———. *Scottie Wilson: The Canadian Drawings*. Regina, Saskatchewan: Dunlop Art Museum, 1989.

McKenna, Kristine. "Inside the Mind of an Artistic Outsider." *Los Angeles Times*, 12 November 1989, 3–4.

Melly, George. *It's All Writ Out for You: The Life and Work of Scottie Wilson*. London: Thames and Hudson, 1986.

———. *A Tribe of One: Great Naive Painters of the British Isles*. Yeovil, England: RONA/Oxford University Press, 1981.

Milwaukee Art Museum. *Common Ground/Uncommon Vision: The Michael and Julie Hall Collection of American Folk Art*. Milwaukee: Milwaukee Art Museum, 1993.

———. *Driven to Create: The Anthony Petullo Collection of Self-Taught and Outsider Art*. Milwaukee: Milwaukee Art Museum, 1993.

Morgenthaler, Walther. *Adolf Wölfli*. Trans. Henri-Pol Bouché. Paris: Publications de la Compaigne l'Art Brut, 1964.

Morrison, C. L. *Realms of the Unreal: The Work of Henry Darger*. Chicago: Hyde Park Arts Center, 1977.

Mullins, Edwin. *Alfred Wallis, Cornish Primitive Painter*. London: MacDonald and Co., 1967.

Museum of American Folk Art. *Self-Taught Artists of the 20th Century: An American Anthology*. San Francisco: Chronicle Books, 1998.

Navratil, Leo, Johann Feilacher, and Michel Thevoz. *Sonneastro: Die Kunstler aus Gugging*. Vienna: Der Kulturabteilung des Landes Niederösterriech und dem "Haus der Kunstler," 1990.

North Carolina Museum of Art. *Heavenly Visions: The Art of Minnie Evans*. Raleigh: North Carolina Museum of Art, 1987.

Parsons School of Design. *Portraits from the Outside*. New York: Parsons School of Design, 1990.

Philadelphia College of Art. *Transmitters: The Isolate Artist in America*. Philadelphia: Philadelphia College of Art, 1981.

Publications de la Collection de l'Art Brut. *Nueve Invention*. Lausanne: La Collection de l'Art Brut, 1988.

Rhodes, Colin. *Outsider Art: Spontaneous Alternatives*. London: Thames and Hudson, 2000.

Ricco, Roger, and Frank Maresca. *William Hawkins, 1895–1990*. New York: Ricco/Maresca Gallery, 1990.

RONA. *RONA Guide to the World of Naive Art*. London: RONA–Naive Artists, 1978.

Rosa Esman Gallery. *European Outsiders*. New York: Rosa Esman Gallery, 1986.

Rosenak, Chuck, and Jan Rosenak. *Museum of American Folk Art Encyclopedia of Twentieth-Century American Folk Art and Artists*. New York: Abbeville Press, 1990.

Schmied, Wieland, ed. *Friedrich Schröder-Sonnenstern*. Hanover: Kestner-Gesellschaft, 1973.

South Bank Centre. *In Another World: Outsider Art from Europe and America*. London: South Bank Centre, 1987.

———. *Patrick Hayman: A Voyage of Discovery*. London: South Bank Centre, 1990.

Spoerri, Elka, ed. *Adolf Wöfli: Draftsman, Writer, Poet, Composer*. Ithaca, N.Y.: Cornell University Press, 1997.

Spoerri, Elka, and Jürgen Glaesemer, eds. *Adolf Wölfli*. Bern: Kunstmuseum, 1976.

Städtische Kunsthalle. *Friedrich Schröder-Sonnenstern*. Düsseldorf: Städtische Kunsthalle, 1967.

Tate Gallery. *St. Ives, 1939–1964: Twenty-five Years of Painting, Sculpture, and Pottery*. London: Tate Gallery Publications, 1985.

Thévoz, Michel. *Art Brut*. Geneva: Editions d'Art Albert Skira, 1976.

Württenbergischer Kunstverein. *Naive Kunst aus Polen*. Stuttgart: Württenbergischer Kunstverein, 1967.

PHOTOGRAPHS OF THE ARTISTS

Consuelo "Chelo" González Amézcua: courtesy of Cavin-Morris, Inc., New York, N.Y.

Eddie Arning: photographed by Gerald Langford at the Villa Siesta Nursing Home, Austin Tex., 1970; courtesy of the Estate of Alexander Sackton

Carlo (Carlo Zinelli): courtesy of the Phyllis Kind Gallery, New York, N.Y.

Henry Darger: ca. 1970; by permission of Kiyoko Lerner

James Dixon: photographed on Tory Island; courtesy of Jill Livsey

Minnie Evans: photographed by Jack Dermid; courtesy of the Cape Fear Museum, Wilmington, N.C.

Johann Fischer: photographed by Martin Vokovits

Johann Garber: photographed by Martin Vokovits

Madge Gill: photographed in her home; courtesy of the Musgrove Kinley Collection of Outsider Art, London, England

William Hawkins: courtesy of the Ricco/Maresca Gallery, New York, N.Y.

Patrick Hayman: photographed with a painted shoetree; courtesy of the artist's wife, Barbara Hayman

John Kane: courtesy of the Galerie St. Etienne, New York, N.Y.

Rosemarie Koczy: 1993; courtesy of the Anthony Petullo Collection

Halina Korn: self-portrait of the artist; courtesy of Alex Gerrard Fine Art, Battle, England

Måna Lagerholm: 1991; courtesy of the Anthony Petullo Collection

Sylvia Levine: 1990; courtesy of Alex Gerrard

James Lloyd: ca. 1972; courtesy of the Portal Gallery, London, England

Albert Louden: 1997; courtesy of the Anthony Petullo Collection

Dwight Mackintosh: photographed by Julie Polunsky in 1993; courtesy of the Creative Growth Art Center, Oakland, Calif.

Jahan Maka: photographed at work in his apartment; courtesy of the Dunlop Art Gallery, Regina, Saskatchewan

Justin McCarthy: courtesy of Epstein/Powell American Primitives, New York, N.Y.

Michel Nedjar: 1997; courtesy of the Anthony Petullo Collection

Nikifor: photograph by Marian Wlosinski; courtesy of the Muzeum Nikifora, Krynica, Poland

Perifimou (Alexander Georgiou): courtesy of the Musgrove Kinley Collection of Outsider Art, London, England

Max Raffler: courtesy of the Collection Susi Brunner, Zurich, Switzerland

Martin Ramirez: courtesy of the Phyllis Kind Gallery, New York, N.Y.

Friedrich Schröder-Sonnenstern: courtesy of the Galerie Brockstedt, Hamburg, Germany

Jon Serl: courtesy of Cavin-Morris, Inc., New York, N.Y.

Bill Traylor: photographed by Charles E. Shannon in Montgomery, Alabama, 1939; courtesy of the Estate of Charles E. Shannon and Hirschl & Adler Modern, New York, N.Y.

Oswald Tschirtner: photographed by Martin Vukovits in April 1993; courtesy of Die Künstler Aus Gugging, Vienna, Austria

August Walla: photographed by Martin Vukovits in March 1993; courtesy of Die Künstler Aus Gugging, Vienna, Austria

Alfred Wallis: 1928; courtesy of the Tate Gallery, London, England

Scottie Wilson: photographed by Ida Kar, ca. 1957; courtesy of the Mary Evans Picture Library, London, England

Adolf Wölfli: 1925; copyright by the Adolf Wölfli Foundation, Museum of Fine Arts, Bern, Switzerland

Joseph E. Yoakum: courtesy of the Phyllis Kind Gallery, New York, N.Y.

Anna Zemánková: courtesy of Cavin-Morris, Inc., New York, N.Y.

PHOTOGRAPHS OF THE ARTWORKS

Larry Sanders Photography, Milwaukee, Wis.: nos. 1–3, 5–8, 10–11, 16–24, 26, 28–36, 38–40, 42, 44–86, 89–96, 98, 100–103, 105–6, 110, 113–17, 119–27, 129–33, 135, 137–38, 140–43, 145, 147–51

Carl J. Thome Photography, Naples, Fla.: nos. 4, 9, 112, 136

Efraim Lev-er, Milwaukee, Wis.: nos. 25, 37, 87–88, 97, 99, 104, 107, 118, 134, 139, 144, 146

ANTHONY PETULLO is president of the Anthony Petullo Foundation in Milwaukee, Wisconsin, and serves on the board of the Milwaukee Art Museum. He earned a bachelor's degree in marketing from the University of Illinois at Urbana-Champaign and subsequently founded Olsten Staffing Services in Milwaukee, where he served as president from 1969 to 2000.

JANE KALLIR is co-director of the Galerie St. Etienne in New York, the oldest gallery in the United States specializing in self-taught art and best known for "discovering" Grandma Moses. Among her publications are two monographs on Grandma Moses and *The Folk Art Tradition: Naive Painting in Europe and the United States.*

MARGARET ANDERA is assistant curator at the Milwaukee Art Museum and curator of the Anthony Petullo Collection.

Designed by Kristina Kachele

Composed in 11.5/16.8 Monotype Fournier

with FF Eureka Sans display

by Kristina Kachele for the University of Illinois Press

Manufactured by C & C Offset Printing Co., Ltd.

University of Illinois Press

1325 South Oak Street

Champaign, IL 61820-6903

www.press.uillinois.edu